The Evolving Picture

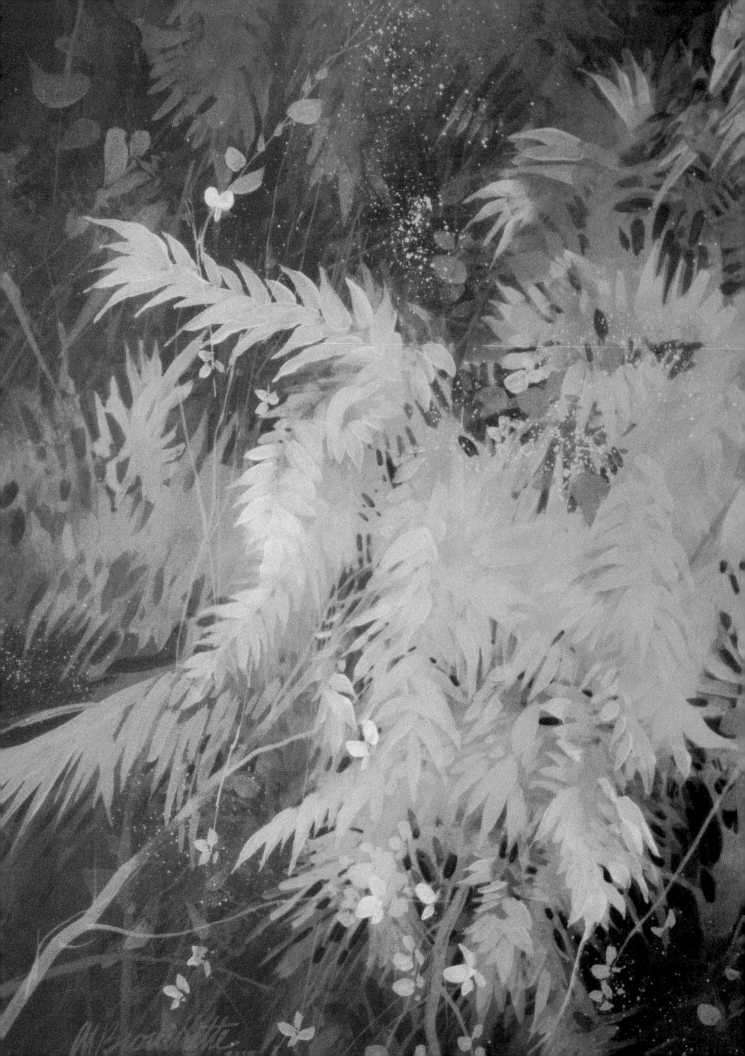

The Evolving Picture

Al Brouillette

Watson-Guptill Publications / New York

To Mary Kathleen Ross Brouillette

THANKS

to Ben Konis, Mary Carroll Nelson, and Christopher Schink for their knowledge and encouragement . . .

to Bonnie Silverstein and Candace Raney who know so well how to put it all together . . .

to the many students who kept telling me to put my thoughts down on paper . . .

and to the one whose dedication outlasted the three years needed to write this book—my wife Kathleen. I am at a loss for words that will adequately describe my appreciation and admiration for her help and understanding.

Copyright © 1987 by Al Brouillette

First published 1987 in New York by Watson-Guptill Publications,
a division of Billboard Publications, Inc.,
1515 Broadway, New York, N.Y. 10036

Library of Congress Cataloging-in-Publication Data

Brouillette, Al.
 The evolving picture.

 Includes index.
 1. Painting—Technique. 2. Painting—Technique
I. Title.
ND1500.B78 1987 751.42'6 87-2019
ISBN 0-8230-1615-3

Distributed in the United Kingdom by Phaidon Press, Ltd.,
Littlegate House, St. Ebbe's St., Oxford

Manufactured in Japan

First Printing, 1987

4 5 6 7 8 9 10 / 92 91

(previous spread)
Nature's Garden, acrylic on illustration board,
22″ × 30″ (55.88 × 76.20 cm).

Contents

Introduction

When I started this book, my initial idea for the introduction was to describe my uses of technique, medium, and design. However, as I began to write, I found I became more involved in describing my efforts to find new ways of expressing who I am, what I believe, and what I feel through my painting.

My first paintings are ample proof of my unswerving committment to the accuracy of rendering and craftmanship, but there is little in them to reveal who the artist is. I think I am typical of most beginners who are pleased when they are able to render a subject accurately, if not originally. I doubt the idea ever entered my mind that there was some reason to paint other than to record the facts of the subject. And because my viewpoint was limited, so, also, were the choices that were available to me. The inevitable result was a carbon copy approach to painting that I became weary of repeating. The scenario was always the same: Select the subject, do a detailed drawing, and render it in color. I could almost do it in my sleep, and I was bored.

As I became more experienced, I began to incorporate the skills I had learned working in advertising; that is, I used the visual effectiveness of value, shape, and spatial arrangement in my paintings and relied less on rendering the subject before me. My first attempts at this style of painting resulted in free-flowing compositions that resembled landscapes. I found that I enjoyed creating these paintings; it was my way of taking a break from the demands of rendering detailed subject matter. I was also aware that each time I returned to the subject-oriented works, I paid more attention to how I felt about the subject rather than how the subject looked. Along with this new awareness, I began to think of detailed drawing as restrictive, and eventually used it only as a guideline. Even so, because of my ingrained habit of faithfulness to my subject, I stumbled into unplanned situations that were difficult to correct. So, in order to make alterations easier, I began to add opaque white to my colors—a technique I use to this day.

This more personal approach to painting satisfied me for a while, but not for very long. I realized I was still involved in two completely different approaches to painting, and I wondered how I could bridge the gap between abstract and realistic images and somehow combine them into one statement. Fortunately, an experience I had one winter several years back presented me with the clue that would guide the way. I saw a dark tangle of flowers, leaves, and small branches scattered on top of the snow. The complexity of forms and color intrigued me so that I photographed the small scene. But later when I saw the prints I didn't have the foggiest idea of what to do with them so I tossed them on a table near a window in my studio. They lay there for weeks until one day I noticed that the sun had faded them to the point where much of the details were obliterated. A process of elimination had taken place without any assistance from me. All I could see in the photographs was a pattern of darks and light. I was encouraged to begin a painting based on the abstract arrangement I saw in the photo but avoided any conscious effort to copy the photo, because that would have lessened the spontaneous reaction to the subject I wanted at the beginning of the painting. And from the first to the last touch, I found myself caught up in a continually unfolding design. Out of sheer activity some of photo's imagery appeared in the painting, but in other areas, the images were altered or even eliminated. Any rules, systems, or formulas were purposely not used.

As I worked back and forth into the darks and lights, I was in no hurry to complete the design. My sole intention was to build a strong abstract foundation that would effectively contribute to the realistic elements that were to come later.

When I did get around to rendering the flowers, leaves, and branches, I was so pleased and confident with what I already had, it seemed no longer necessary to include every visual fact in order to enhance the painting. By the time I had completed the painting, I had made more intuitive choices than I could count. For the first time I had reached inside myself to reveal images I didn't know I had. I was genuinely surprised to realize I was their author. The essence of this experience is touched upon by American artist Ben Shahn in *The Shape of Content:* "If a painting is to be at all interesting, it is the very absence of formula that will help to make it so. If forms are reduced to a certain common quality, a unity, that is because they proceed from a personal vision."

I believe the originality of your work will be in direct proportion to the number of choices you make. Your selection of subject, the evidence you uncover about it, the way you perceive and interpret what you have found, all of these factors will contribute to your painting's identity. What you take out and what you leave, emphasize or diminish, and the way you choose to arrange your material on your surface will all testify that your painting is an original and yours alone.

Careful planning is an important beginning and a firm grasp of your medium can provide an ending; but

between these two basics is an enormous expanse that can be entered and traveled only by you. It contains the essential and vital ingredients of your reactions and your instincts. As D. H. Lawrence said in *The Creative Process:* "The knowing eye watches sharp as a needle; but the pictures come clear out of instinct." Once instinct and intuition guide your brush, the picture will happen.

Today, I have come to realize that craft is the least important consideration when I am trying to determine the quality and effectiveness of a painting. The arrangements of elements on the painted surface and the originality of imagery are more important to me. Nevertheless, for the beginning artist, the first challenge is to control your medium. That is why I try to convince beginning students to focus their thoughts on specific subject matter and paint what they see. However, in the long run, if you describe every blade of grass each leaf in a tree, all the ripples in a wave, and the exact details of a face, you won't have accomplished anything that countless other artists couldn't do. In the words of Ben Shahn: "Craft is that discipline which frees the spirit, and style is the result." Thus it is only after you can handle the technical problems that you are then able to become truly expressive.

In order to get away from simply recording what you see, you can begin to transform your subject by using such design elements as value, color, edge quality, movement, texture, line, shape, emphasis, repetition, and variety. These are what I call the language of art. They can be interpreted and applied in whatever way you choose to use them, and as you begin to gain confidence in this approach, you will be able to do what no other artist is capable of doing. You will be able to use the painted image to reveal the person within. That realization is powerful stuff.

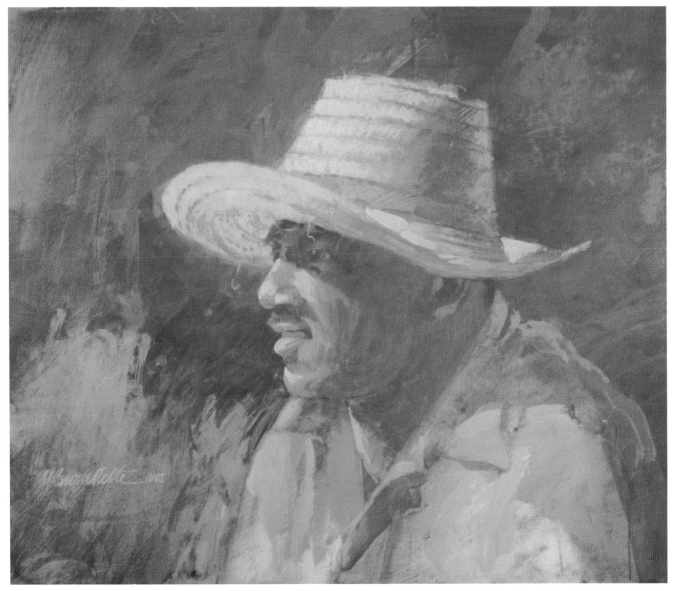

The Bahamian, acrylic on illustration board, 11" × 13" (27.94 × 33.02 cm).

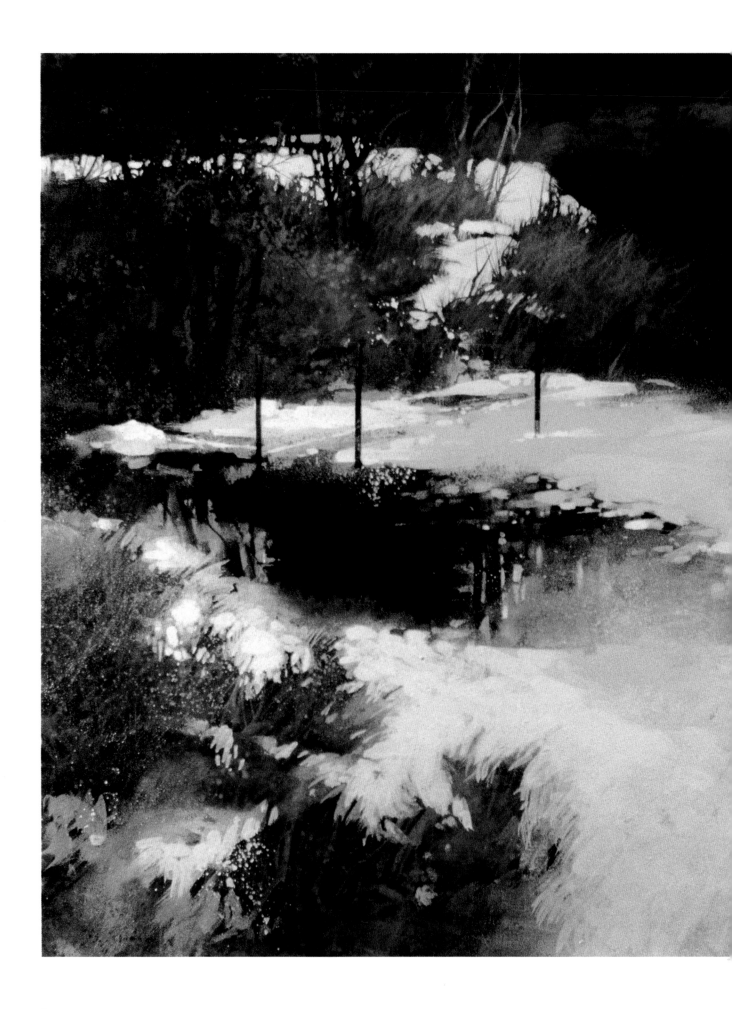

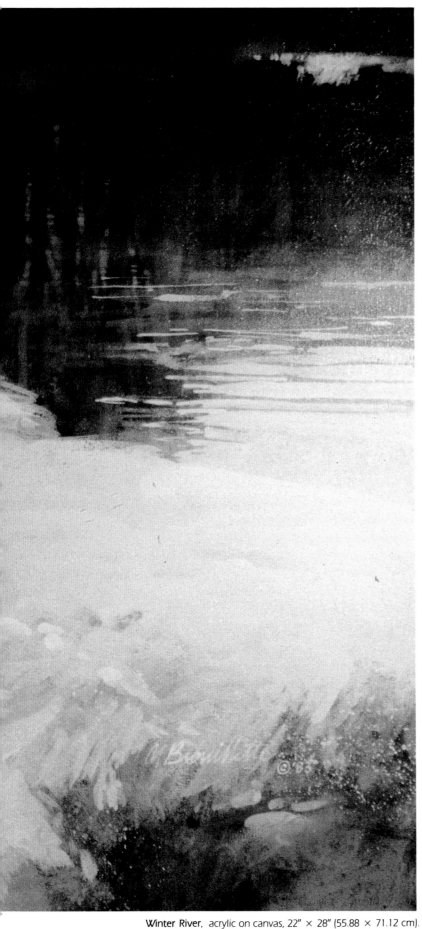

Search for the Painting

Winter River, acrylic on canvas, 22" × 28" (55.88 × 71.12 cm).

Why the Camera?

It amazes me that I wasted so much time trying to be an outdoor painter. Learning the routine that best suits you does take time, but when you find it, stick with it no matter what anyone else's approach is. It makes no difference whether you work outside all of the time, in the studio all of the time or if you start works out-of-doors and complete them in the studio. What does matter is the quality of the painting that you've done.

When I did work outdoors I painted small because it was convenient. What I painted was more from my imagination than from the subject. I rarely even looked at the subject. So when I returned to the studio to develop a larger painting, it didn't work. The painting lacked the immediacy and spontaneity of the original. Trying to duplicate what I had already done was like trying to copy an emotion.

Now I work exclusively with the camera. All of my planning and preliminary work is done in the studio with the aid of slides and photographic prints. The slides are taken during my excursions outside. The camera is a valuable asset because, first, it is compact and light; second, I can gather a lot of material in a short span of time; and third, I can record on film constantly changing light patterns, the movements of living things, or the transitions of weather.

I have a Canon AE-1 with a 85 to 300mm telephoto macro lens. I also have a 35mm lens that I use a good part of the time. With this combination of lenses I can do a lot of composing and editing right on the spot. The more thought you give to the particulars of what it is you want *before* you take the photograph, the more relevant will be the material that you've collected.

Your memory may be fairly sharp, but some days may elapse between the time you take a picture and the time you get it back from the processor. So it may not be a bad idea to keep notes about what you were thinking and feeling in relation to your subject. What was your first impression? Why did you stop to photograph it? Was it the shape, color, texture, contrast, simplicity, atmosphere, or the light? Were there sounds, intense heat, or bitter cold? What made this particular moment significant? Anything that you can write down to jog your memory later on will be of help.

At times you may run out of material to paint. That can be a problem especially when your painting time is limited and you don't want to miss the opportunity to work. When I am short on time, I load up my Polaroid SX70 with film and go about looking either on foot or by car for material that will give me something to work with. I am sure there are well-informed individuals that can get a better Polaroid photo than I can, but under existing circumstances I can settle for anything that may trigger my imagination.

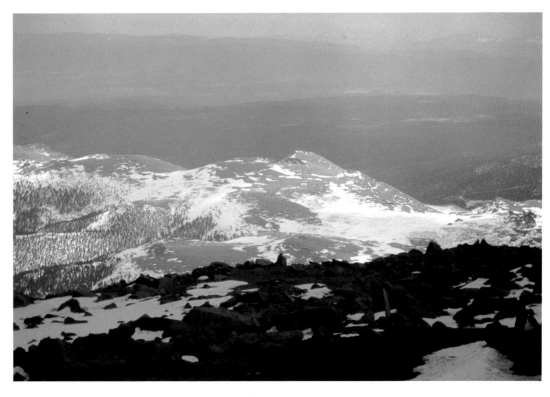

You can capture the entire panoramic view or pinpoint specific aspects of the scene for a variety of exciting effects. It all depends on the emotions or concept you want to project.

Decide what to include

When looking at this mountain scene, you need to decide what part of the photograph you want to paint. Do you want a close-up of the mountains or do you want to include a large area of the sky? Would you rather eliminate the sky and include the trees moving down the mountains' slopes? Is it the arrangement and flow of the ever-greens down those slopes to the fields below that are interesting or is it possible that the patchwork breakup of the fields rolling toward the base of the mountains is what you would really like to have emphasized in your slide? Remember, only you can know what elements have the most potential for your paintings.

Emphasize the weather or time of day

You can photograph out-of-doors in all kinds of weather conditions without having to battle the elements as you would if you were painting on the site. In some instances you don't even have to get out of your car to get the shot you want, though if you do, the time spent getting the right angle need not be lengthy.

If it is a clear day with the sun shining, I prefer early morning or evening light because of the light's low angle, the deep shadows, and the sharp contrasts. During days of rain, fog, or snow the time of day need not be a consideration. You can get some great photographs on overcast days that might otherwise be ordinary because of the softening, simplification, and transformation of nature and architecture.

Determine the horizon and line of sight

Beach Ground Cover, acrylic on paper, 21" x 29" (53.34 x 73.66 cm).

Our normal line of sight seems to be on a level with the horizon. You might consider a high horizon with plenty of foreground or a very low horizon with plenty of sky. An even more unusual line of sight would be photographing straight up above your head or right down between your feet. On one occasion I took a series of pictures of a grape arbor from inside the arbor, looking straight up through the leaves, vines, and clustered grapes into the sun. The perspective was so exciting I shot a whole roll of thirty-six. At another time I took some pictures looking straight down between my feet at ground cover and rose hips moving across the white sand. In that situation I took photos from the standing, bending, and squatting positions plus close-ups with my macro lens.

Create—Don't Copy!

While being of great assistance for collecting information, the camera can have a negative influence on those who rely too much on the content of the photograph. Don't be dictated to! Make every effort to alter, change, and rearrange the material in the photograph into your personal statement. If the subject is depicted in warm colors, consider painting it in cools. If there is sharp contrast, paint it in close values. If the image is bright colors, you may want to neutralize the color intensity by mixing. Other helps are taking your photograph slightly out of focus so

that you cannot see all the little details, or shooting with black-and-white film only, so that color selection would necessarily be of your choosing. Remember, the camera is only a means toward an end, not an end in itself.

I never copy photos—nor should you—even if they're your own. But even if I were to use someone else's photography, I would interpret it from my own point of view. And so I'm sure that one of my photographs in your hands would result in a painting quite different from mine.

Sometimes no plan at all can be the best tactic when a subject is extremely complex. In these situations I'm more likely to find my way if I don't have a preconceived plan, such as a value study. The idea for this painting came to me at the time I was photographing the flowers. As you can see, close-ups were taken using slightly different compositional arrangements. Once the slides were developed I took the film out of their cardboard mounts and sandwiched them into one side holder. Although I didn't want to imitate what I had photographed exactly, I did incorporate some of the combinations of shapes and colors into the painting.

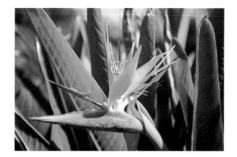
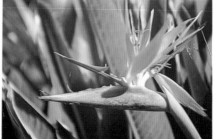
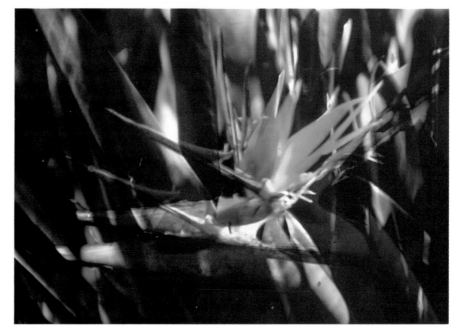

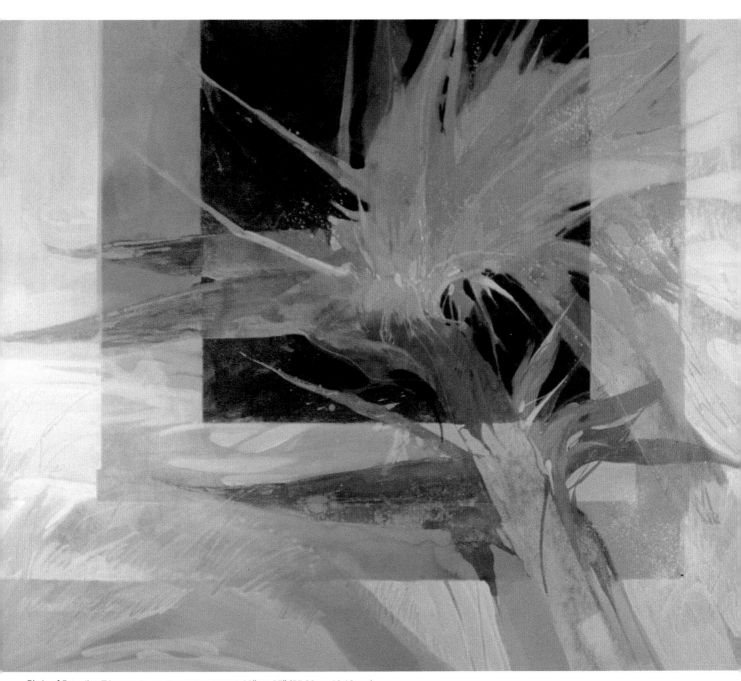

Birds of Paradise Trio, acrylic on illustration board, 22″ × 27″ (55.88 × 68.68 cm).

Viewing your Prints with a Factual Eye

Although I initially take slides of my subjects, I convert the ones I plan to paint into prints for convenience. Then I look at the photo very carefully. Don't be in a hurry at this stage. By now you have a mental image of what the design might be, but the design alone is not enough. The details of your subject need to be understood *before* you pick up your brushes. It makes little difference what school of painting you are working in, realism, impressionism, or abstraction. You must know the facts of your subject if you are to be able to know what to put in, take out, rearrange, or alter. More than a casual glance is necessary if you are to become aware of the information these pictures contain.

Seeing requires a conscious effort on your part that is necessary in order to absorb all of the details inherent in your subject. At this time our normal tendency might be to "turn off" so that our ability to *see* is pared down to the basic necessities of daily living. As a visual artist, you need to separate yourself from your normal habit and open your eyes during a walk through the forest. What the woodland contains will not reveal itself to you unless you linger a while.

When you look at your photographs for the first time, the results can be similar to entering a dark room. There is little that the eye can see, but as your eyes adjust to the darkness, the interior of the room becomes visible. Likewise, the material contained in your photographs is always present. It just takes a little time to see it.

Once you sense that you have learned what you can from your photo, you might begin considering how you are going to go about translating what you know into a painting. I usually make that transition by getting involved in a contour drawing that focuses my attention not only on the subject but on my subject's relationship to the spaces around it. At the same time I am considering color, shape, movement, edge quality, value, and line: the *language* of painting.

Below is a typical example of what I mean:

The visual facts

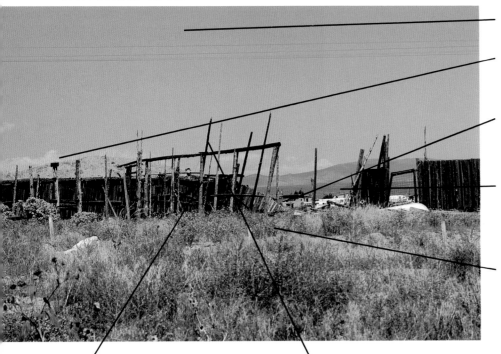

The sky area is a flat solid color and it is the lightest value.

Low clouds are massed against the distant mountains.

Just beyond the fence are one-story buildings and mobile homes.

The fence line has solid and broken areas. An opening in the fence is apparent just to the right of center.

The foreground is composed of light and middle values that contain lavender and yellow flowers silhouetted against the dark fence.

The poles standing in front of the solid areas of fence appear to be light against dark.

When the poles intersect the sky, they appear to be dark against light.

Artistic interpretation of visual facts

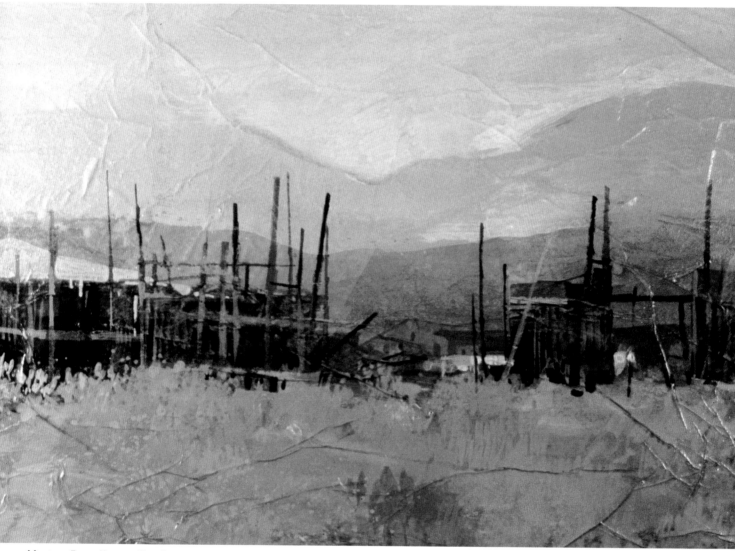

Montana Fence Line, acrylic collage on illustration board, 15″ × 15″ (38.10 × 38.10 cm).

The variety of values, shapes, and sizes in the fence line is what caught my attention when I looked at the slide. I planned on isolating the dark fence by developing the sky and ground area in lighter values. The small buildings and mobile homes would be used as a secondary focal point to bring the viewer's eye deep into the picture plane. The center of interest is along the fence line just to the left of center. As I painted the fence shape, I made a conscious effort to alter its size, value, and edge. Other considerations were the warm, neutral ground colors moving toward the fresh cool colors of the mountains.

Facts and Interpretation

My paintings always begin with facts taken from nature, but along the way, I make the subject my own. The transformation begins when you add the element of self to the visible world.

Personal selection is important if your sketch is to reflect your choices, so don't hesitate to rearrange, alter, or edit wherever you think it is essential for improvement of your design. Your personal selections and the application of your design ideas will result in an original drawing.

If you faithfully render all the blades of grass in a field, the rocks on the beach, the ripples in the water, or the leaves in the tree, you have only accomplished what anyone with a camera and a roll of film could easily do. And, in fact, hundreds of painters could probably render it more accurately than you could. On the other hand, if you choose to express yourself through an *original concept* (worked out through the charcoal design composition), you will have created a unique, personal approach to your subject, something no camera or other artist could possibly match.

Facts. A shallow expanse of dark, shallow water is broken by flat outcroppings of light granite. The continuation of the granite slabs is visible just below the water's surface. A small cluster of branches and leaves appears at the lower right corner of the photograph.

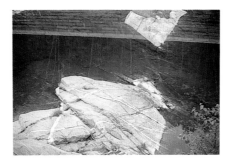

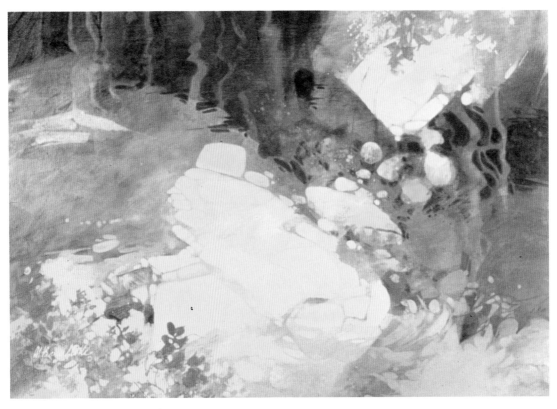

Quarry Pool,
acrylic on Masonite,
22″ × 30″
(55.88 × 76.20 cm).

Interpretation. The light-dark pattern seen in the photo is not very interesting, so I altered the arrangement by lightening the value of the granite where it moves below the water's surface and added middle and small-sized rock fragments. These changes improved the overall shape and distribution of the light area.

Then the dark area was rearranged, which automatically altered the negatives. The darks were fragmented further by middle and light-value reflections and water movements.

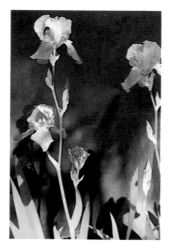

Facts. A group of flowers, buds, stems and leaves is silhouetted against a flat, dark background. Although the color is vivid, the composition and values are not particularly compelling to me.

Interpretation. I saw this picture as a pattern of flowers confined to the upper half of the painting, with the lower section containing simple vertical movements. The comparison of an animated area and a quiet area made me think about a more subdued color and value arrangement. In contrast to the actual irises, I visualized a painting that was serene and softly colored.

Lifting Fog, acrylic on illustration board, 15″ × 15″ (38.10 × 38.10 cm).

Facts. A hill covered with dark foliage runs horizontally across the picture plane. The water at its base is also dark. The sandy exposed areas are light and they descend vertically down to the water. A middle-value sky moves horizontally across the top of the picture.

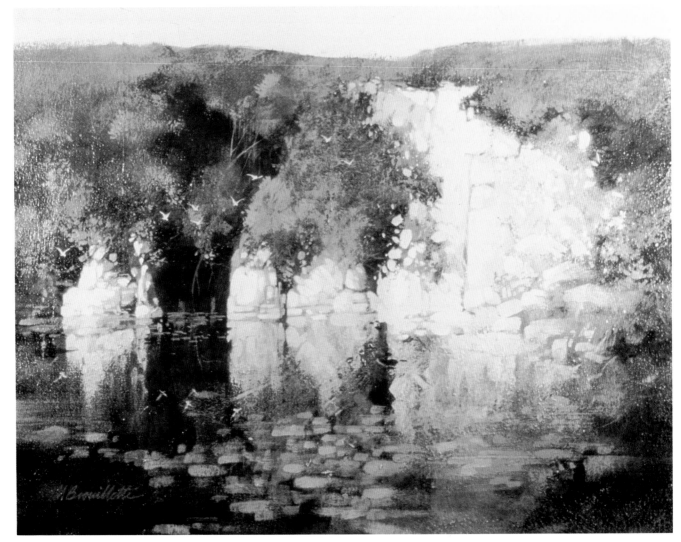

Cliffs at Fort Hood, acrylic on canvas, 16" × 20" (40.64 × 50.80 cm).

Interpretation. The hill and the water would be developed as one shape by the use of similar values in both areas. This unity would be furthered by obscuring the waterline as it meets the cliff and also by indicating very little value change between the sandy cliff and its reflection. The results of this manipulation would heighten the visual strength of the shape with the greatest potential for design development—the sandy cliff. To do this, the values at the top of the hill were lightened where the cliffs turned to receive the light from the sky, resulting in a softer edge. The sharpest edges are now located well inside the picture plane. The seagulls were added to give scale to the hill.

Facts. A grouping of abandoned stone buildings forms a dark shape across the middle ground of the landscape. Low mesas and mountains form a middle-value shape against the sky. A light, sun-drenched ground area constitutes the lower portion of the photograph. A grouping of trees breaks the horizontal movement of the buildings.

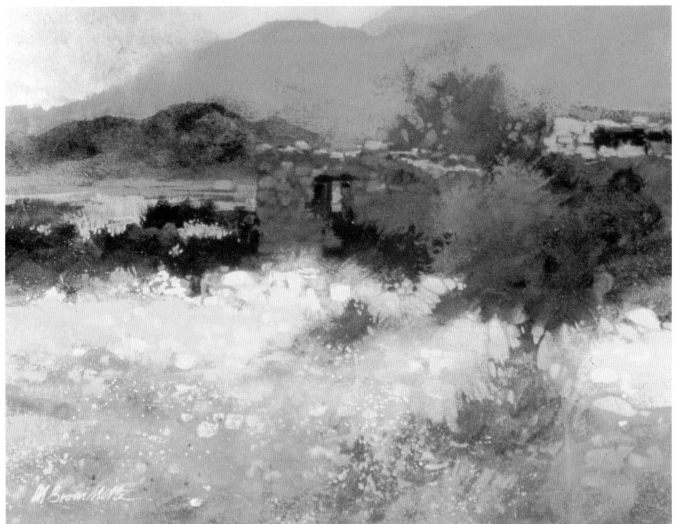

Ruins at Terlinqua, acrylic on canvas, 18" × 24" (45.72 × 60.96 cm).

Interpretation. The value arrangement of the painting is true to the photograph: dark and middle values at the top half of the composition, light values in the foreground. I have lessened the picture's depth by enlarging the mountains so that their cool masses contrast with the warms of the desert floor. The ground area now moves off into the distance, and the trees play against the mountains and thrust downward into the foreground space. Both of these additions provide a link between the upper and lower areas of the painting. The interlocking shapes of mountain, mesa, ground scrub, and building now incorporate an outline that enhances the overall quality of the painting.

An awareness of the importance of the outlines of the large value masses of your paintings will improve your work. Take all the liberties you feel are necessary. Keep in mind that shape is more important than subject.

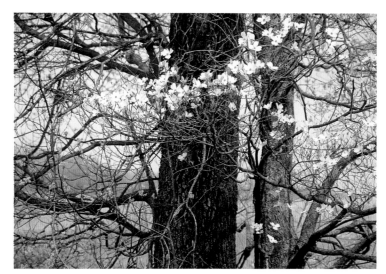

Facts. Two dark trees, one large and one small, rise vertically through the photograph. Numerous branches crisscross the light background and move in front of the dark trees. Dogwood blossoms are scattered in random fashion throughout the picture surface.

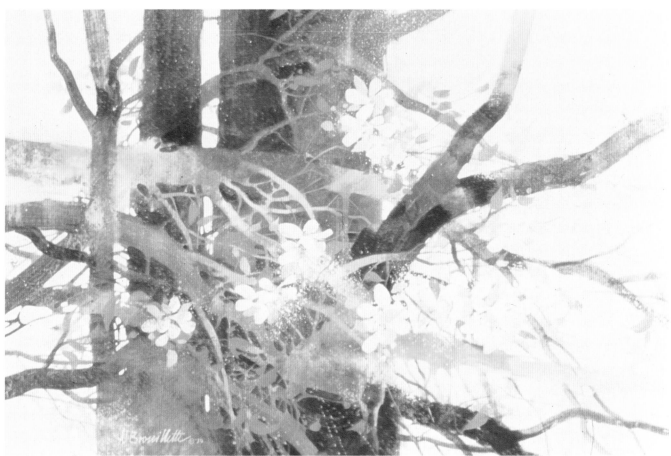

Dogwood, acrylic on canvas, 21″ × 29″ (53.34 × 73.66 cm).

Interpretation. Franz Kline's black-and-white abstractions were and are a strong force in my awareness of the abstract quality of realistic painting.

I started with a strong, slashing black-and-white composition that seems so reminiscent of Kline that I could have been accused of copying his work. When I thought the design could stand as a visual statement by itself, I gradually nudged it toward an objective imagery of trees and wild flowers.

When the painting was completed, it contained all of the elements of a normal woodland scene. What lifted it above the ordinary was the concept underlying the visual imagery.

It would be foolish of you to try to remove yourself from artistic history, especially that of the 1930s through the 1960s. As an artist living now, you are affected and you are a recipient of the artistic theories that surfaced at that time. If you take the time and make the effort to learn why artists painted the way they did, you can reap the harvest of their struggle. If you understand the thinking of a Mark Rothko, a Jackson Pollock, or a Franz Kline, you will paint a much more expressive tree, barn, or cow.

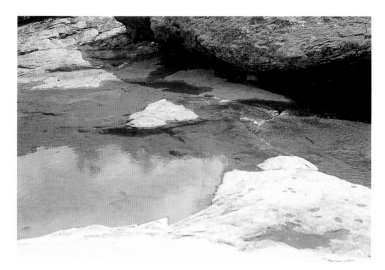

Facts. A large boulder, rocks, and shadows make up the top part of the photograph. The middle portion is an area of slow-moving water and reflections. The foreground contains a flat sandstone shape.

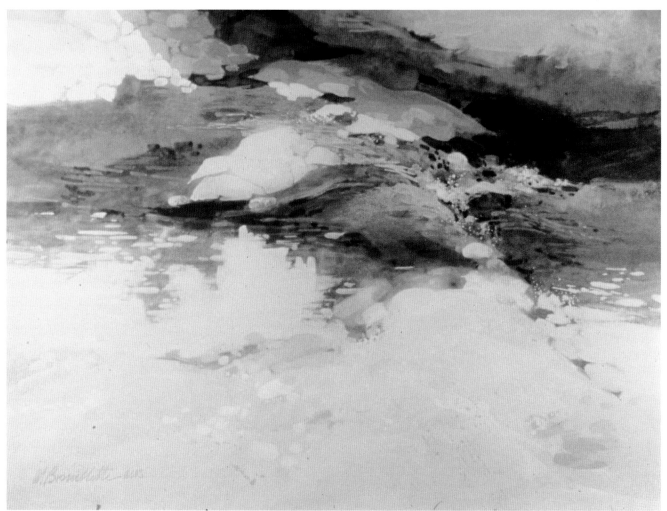

The Sound, acrylic on illustration board, 19¼" × 25" (48.90 × 63.50 cm).

Interpretation. All of us are stimulated by different visual situations. My eyes focus on areas of dark and light composition. Simplicity of content and structure is an added incentive for me. All of the above elements are present in this photo: a light area at the top and bottom of the photo with a dark shape suspended between them.

I painted the dark area first and developed it until I thought its configuration could stand as a visual statement on its own. No effort was made to imply water, rocks, or reflections. The objective, more realistic imagery could be added once the design-composition was completed.

No two people see or respond in exactly the same way. That human quality can contribute to the originality of your work if you will trust your intuition.

The Value Arrangement

The value design composition will provide us with important information about the placing of the value arrangement within the picture plane. The value sketch is not meant to be a complete work of art. Its sole purpose is to help you see your subject in its simplest form. Minimal description is advised so that the foundation of your painting will be held intact as a guideline for your placement of the light, middle, and dark values. Keep the drawing small so that you will be inclined to block-in the two or three dominant shapes in their purest form. Avoid focusing on the details of your subject. Concern yourself with mass, value, and size.

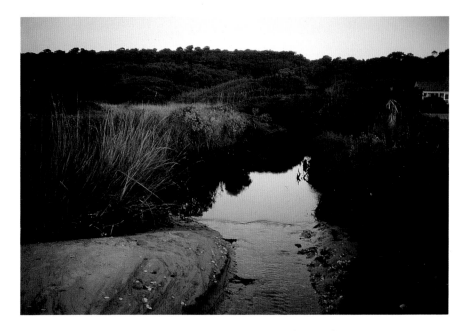

This photograph lends itself to simple value divisions. The sky, rock, and water are the light values and the marsh grasses make up the middle to dark values.

Look for interesting value patterns

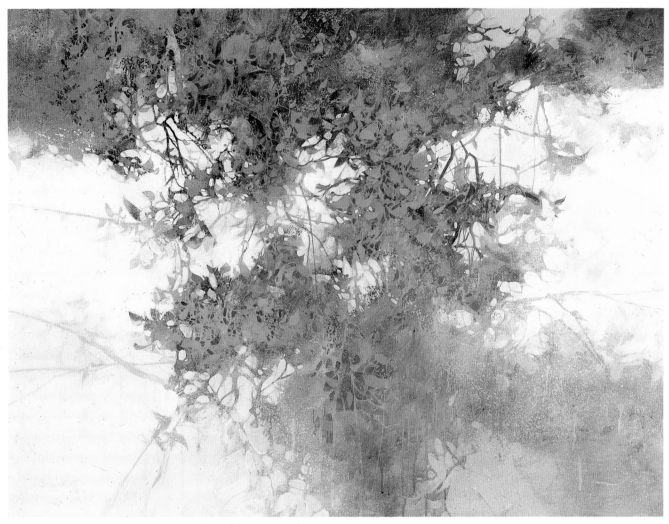

Good Harbor Beach, acrylic on Masonite, 35" × 48" (91.44 × 124.46 cm).

Working on smooth tracing paper with black and sepia inks as dark and middle values, I reduced this clump of vegetation into a simple three-value sketch. The dark green ivy interspersed with brilliant red becomes an interesting dark abstract shape interplayed against the light background of the sand.

Make an abstract value arrangement

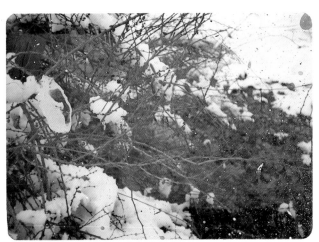

Photograph

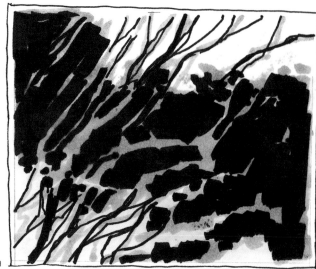

Value sketch

This photo resulted in *A Flame in Winter.* I was attracted to the picture because of the contrast between the horizontal ground movement and the vertical countermovement of the branches. I also wanted to express the way the value of the tangled branches changes from dark to a middle tone as they move from the light value snow area to the dark underbrush.

Most of my paintings begin as abstractions. In this particular work, I developed the dark shape without any obvious reference to subject matter.

My only goal was to create a composition that would be exciting in itself. I do not go beyond my basic arrangement of darks and lights until I am convinced that the viewer will approach the painting because of the design, not the subject.

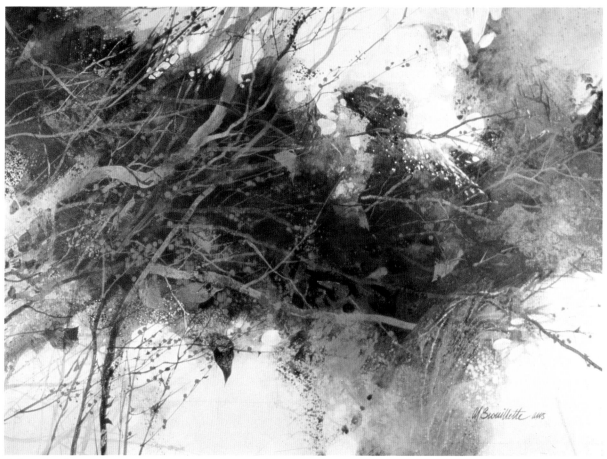

A Flame in Winter, acrylic on illustration board, 20″ × 26³/₄″ (50.80 × 67.95 cm).

A light shape suspended between darks

Photograph

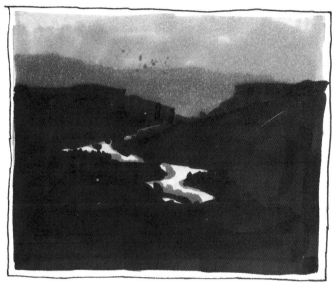

Value sketch

The reason I decided to paint this scene is because I wanted to capture the beautiful, swirling shape of the Rio Grande set off by dark hills. Note that the value changes in the mesas and hills were close, but still visible enough to indicate the plunging nature of the land down to the canyon floor.

The photograph for this painting was taken on a wet overcast day. Little light was available to give shape to the mountains and hills. The simplicity and flatness of the subject presented in the photograph would have been less than interesting had I not taken some artistic liberties in order to indicate the monumental impressiveness of the location.

The distant areas were kept quiet in order to emphasize the feeling of space and distance. More description was added to the middle ground shapes to indicate their movement into the canyon. The foreground was broken up with warm colors and numerous shapes and edges in an effort to imply bushes, trees, large boulders, and ground movements.

Don't be afraid to translate your subject freely in your own personal way. The choices you make will place the stamp of originality on your work.

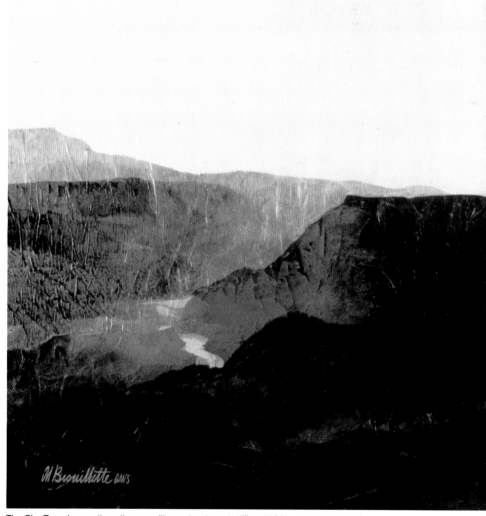

The Rio Grande, acrylic collage on illustration board, 15" × 15" (38.10 × 38.10 cm).

A light shape moving against a dark shape

The idea for your painting should be understood before you start to paint. Your goals must be maintained to the completion of the work. Once you think the idea has been realized, there is no need to continue. The painting is completed.

The concept of *Light on the Water* is the strong contrast between the darks and the lights and the intrinsic beauty of both these kinds of shapes.

The darks and the lights are not independent units; they receive their beauty by their relationship to one another. The edges of these shapes are not constant, but are everchanging. Light, then dark. Cool and warm. Hard, changing to soft edges.

Remember, shape is more important than subject. If you want to check out the visual interest of a shape in your painting, isolate it by making an outline of it on tracing paper. If the shape is not interesting to you in itself, then it will be less impressive as a mountain, lake, rock, or figure.

Photograph

Value sketch

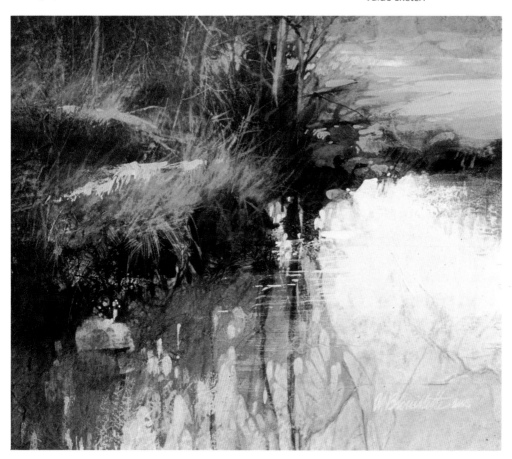

Light on the Water,
acrylic collage on illustration board,
13" × 15" (33.02 × 38.10 cm).

A light shape suspended between middle and dark values

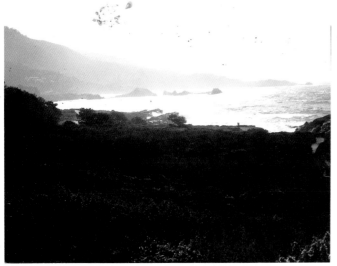

Photograph

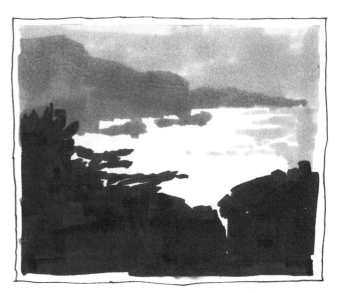

Value sketch

The morning sun was beginning to melt away the coastal fog, and the ocean's surface was glittering from the sun's rays. This combination of bright water and misty hills was very striking and I thought the scene might make an excellent subject for a painting. Unfortunately, when I photographed this view, the slide that resulted lost quite a bit in the translation. But coupled with what I remembered, there was still enough information for me to begin painting.

Since the middle-tone fog and pale water were close in value, I decided to unify them into a larger element in the painting. I enhanced this light shape by creating arrangements along the shoreline that would change its natural outline. The immediate foreground consisted of a horizontal movement with little variation in direction and even less of interest in its interior detail. I reshaped the foreground's edge with vertical counter-movements and also added touches of vibrant pink and green color.

Once the light and dark arrangement was determined, I took every opportunity to improve the interest in the contour of each shape. I also increased the value contrast to create a center of interest where the light water and the base of the dark mountain meet.

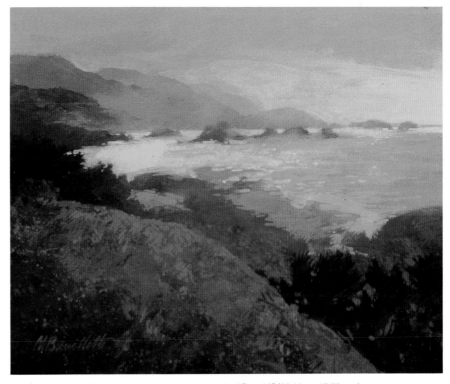

Pacific Coast Morning, acrylic on illustration board, 15″ × 18″ (38.10 × 45.72 cm).

Viewing your Slides with an Artist's Eye

When my film is developed into slides, I project them onto the wall of my studio. The size of the image usually corresponds to a full sheet of watercolor paper. I darken the studio so that the image projected is at full strength. That first impression can be a deciding factor in the selection process.

I find that translating a complex subject into simple flat shapes happens immediately, if it's to happen at all. Pushing subject out of my mind, I allow familiar objects to be replaced with shape, value, and contrast. All details are filtered out until simple, large patterns of light and dark emerge. If you have problems seeing these patterns, simply try squinting through your eyelashes. If the subject is a leafless bush in the snow, the resulting pattern might be a dark shape moving between light areas.

Look your slides over carefully for painting ideas. You may be in for some pleasant surprises. During the slide selection process, observations other than the value-shape arrangements can trigger your imagination. The *unexpected* can offer you an entirely different perspective on a subject.

I only select a few slides to develop into color prints. I return the rest to their containers and rarely view them again. I find it difficult to go back and rehash old ideas. My first impression of a slide is usually a lasting one. I'm never sure when my next opportunity for a painting will be triggered by a slide, but I know it when I see it.

I am not a professional photographer, which can become painfully evident as I look at film that is overexposed, underexposed, out of focus, or photographed without any forethought of what I wanted to do with it. In some cases, the slides bear little resemblance to the subject. My reaction can be one of frustration, but this is not always the case. Occasionally the shock of the unexpected can be a greater force toward developing a new work than viewing something you expected.

Two examples of this sort of response occurred within the past year. The first incident was the result of an overexposed, out-of-focus slide of a winter mountain scene. The image on the film was so hazy, that I was free to reconstruct the subject entirely through my imagination, and the result was the painting *Above Red Lodge*.

The second example came about by accident. I had removed from my camera a roll of film that was partially used, but I forgot to note this information on the container. Three weeks later, I reinserted the film in my camera and, as is normal, exposed the film from the beginning through the end of the roll. My first reaction when viewing these slides was one of surprise, but that was immediately replaced by the pleasure of seeing nature revealed in a completely new way. The double exposures caused overlapping subjects to change color and value as they crisscrossed each other. Some of the shapes were fragmented into dozens of small color notes. The acrylic painting *Kaleidoscope* is the result of this happy accident.

Since the above experience I have experimented with the camera and have figured out a way to develop double exposures under more controlled conditions. You can talk to the people at your camera shop and I am sure they will be happy to advise you on a procedure that will be workable with the particular type of camera you have. If it is not possible to get a double exposure with the equipment you have, there is another approach you can use. Take two slides of your choosing out of their cardboard mounts and sandwich them into one mount. The combinations of subjects possible in this way are endless.

Double exposure

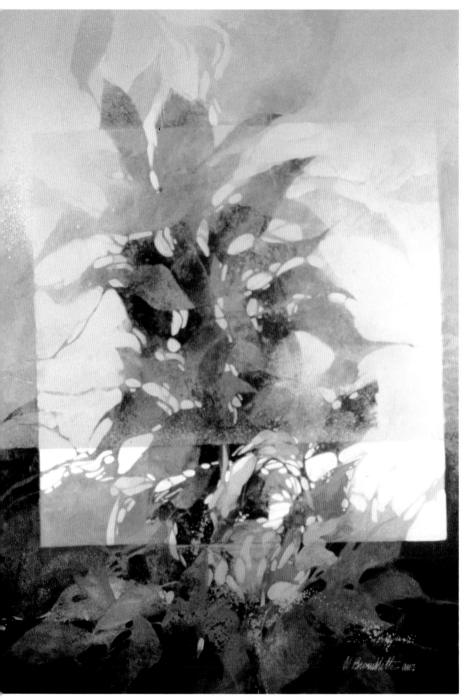

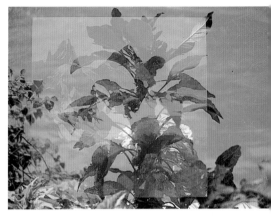

As artists, we expend a lot of time and energy looking for something to paint. Quite often we paint because it is a part of our daily schedule. Other times we are on a painting holiday with other artists and feel a compulsion to paint *something*. The times when we are actually *inspired* to work seem to be few. That is why it is a welcome pleasure to come upon a situation that seems to be tailor-made for us. Such a situation occurred when I accidentally photographed a double exposure. The result was such a departure from my normal way of seeing that it was like a breath of fresh air. A close-up view of a plant was superimposed on an geometric image. The result was an eruption of fragmented shapes and colors.

I am not sure that moments of inspiration produce better paintings, but the experience can be very pleasant. Our ordinary day-to-day painting situations, while not being inspirational, result in the larger proportion of our works, some of which are very creative. Most often inspiration arises out of the *act* of painting.

Kaleidoscope, acrylic on illustration board, 22″ × 30″ (55.88 × 76.20 cm).

Let your imagination loose

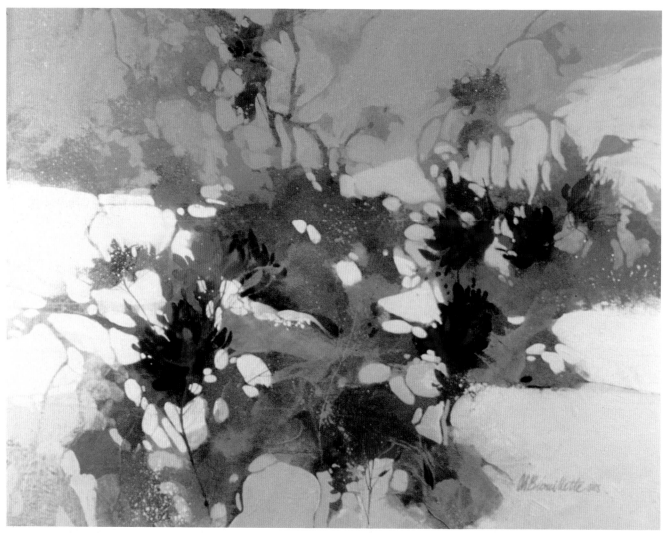

Fall Snow, acrylic on rice paper, 22" × 27" (55.88 × 68.58 cm).

Almost anything can trigger the imagination. For example, *Fall Snow* was the result of two Polaroid shots. It was successful enough to be included in a national exhibition. It made me realize that original work is largely of the imagination.

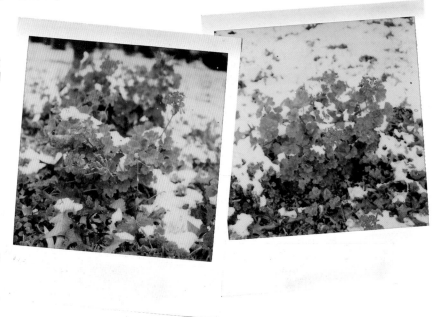

Out of focus

Although this photograph is clearly out of focus—and paint-spattered to boot—it served as a reference for *Kaleidoscope*. The fact is that sometimes lack of information can force you to rely on your imagination. The results may be indicative of your ability to tap resources that are a part of what you have learned from experience

A combination of dreaming and practical knowledge can supply you with a very pleasant painting adventure. A hint of the joy you felt as you progressed through the work will be evident to the viewer.

Your freedom of personal choice is important as a creative artist. Don't be afraid to rely on your instinct. **You** are what makes your work one-of-a-kind.

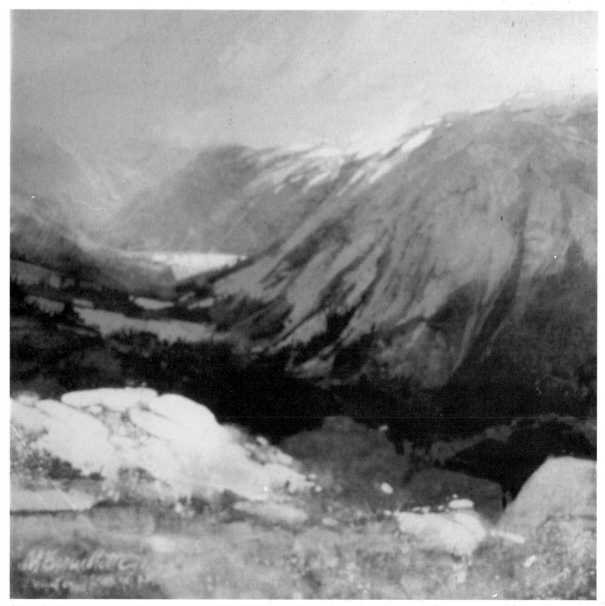

Above Red Lodge, acrylic on illustration board, 15" × 15" (38.1 × 38.1 cm).

Moving from Fact to Fancy

You now have the information that will help you to consider the possibilities of your subject as a painting. The facts you have learned from your photograph will assist you in reaching meaningful artistic conclusions, but now you have to compose your subject artistically.

The placement of your subject in relation to the areas around it should be resolved first. You might be able to think your way through this problem, but I find it easier to do it with a drawing. I can also relate a drawing more readily to a painting because they are both on flat surfaces. I use a ball-point pen so that each line is *equal* to every other line. The result is a *pattern* whose many parts are visually equal. You might think of the drawing as a jigsaw puzzle rendered in line.

You can begin the drawing at any point just as long as the line flows from one area to another in a continuous progression. Background, middle ground, and foreground are thought of as flat interlocking shapes. Positive and negative areas are drawn with identical clarity. No rank should exist among them.

Line analysis

Look at these drawings of a ball and box. Can you see how these subjects are related to the space around them?

Another dimension will appear as you develop the drawing. Your confidence in your ability is increased because you *know* your subject. Your positive attitude now allows your hand to move freely and naturally. Your hand will move in directions that were not planned, and you will create shapes, lines, and movements that are not evident in your subject. You have now transformed the drawings of the ball and box into personal statements. It is because you know your subject that you are now able to add to, change, or leave its confines to the degree you desire. You have crossed the bridge from visual facts to a free interpretation of facts coupled with personal imagination. Your drawing is now as individual as you are.

Ball in a square

Box in a square

Free interpretation of ball in a square

Free interpretation of box in a square

Translating nature into art

Let's enlarge on these ideas with an interpretative drawing of a landscape scene. The subject is a lake at sunrise. The far shoreline moves horizontally across the upper half of the photograph. The trees are silhouetted against a light sky. The foreground is a large area of water with reflections.

The drawing shows adjustments in the sizes of the trees and reflections. These areas have been enlarged; the sky and nonreflecting water are now smaller. I wanted the trees and reflections to dominate the picture's surface. A great deal of improvisation has developed in the reflections. The overall outline of the darks is much more interesting as a shape, which consequently improves the profile of the light shapes.

Do a landscape drawing and see how many artistic liberties you can take while still maintaining the look of your subject.

Landscape interpretation

Charcoal Techniques

Vine charcoal is a painterly medium. That is, you can apply it quickly, remove it rapidly, and lighten its value or increase its density without the hassel of smudging, smearing, or spotting.

I used to do value studies with B pencils, developing the drawings in a sketch pad. By using the side of the lead I could quickly render simple compositions. But with this medium I was unable to lift the lights out of the gray areas without smudging the surface. So I switched to charcoal and now do my sketches on smooth drafting paper.

The illustration shows you how light shapes are cleanly lifted out of the dark charcoal with a kneaded eraser. The light lines are done in the same way. All you have to do is *shape* the eraser to get the desired effect. The grays are developed by lifting some of the charcoal with a tissue or a clean compressed-paper stump. The light gray lines are done with the point of the stump; the dark lines, with a charcoal pencil.

Because of the smooth surface, I can distribute the vine charcoal over the desired area, blend it smoothly with a stump, and, by methods of addition and subtraction, create a design for my painting in a matter of minutes. Charcoal is quick, exciting to work with, and painterly in the sense that it can be move around the surface of the paper, subtracting from one area and adding in another. Other charcoal techniques include drawing and lifting with the stump and the kneaded eraser as demonstrated in the chart.

Some people think that charcoal is messy, and that can be true for those who lack experience. I have three suggestions that will assure you of a clean drawing.

1. Don't blow loose charcoal off your work surface. Hold the drawing over the trash can face down and lightly tap the back of the drawing.

2. Do not allow the fingers or the ball of your hand to touch the drawing. If you need to touch the surface, place a piece of clean paper over the area of the drawing where your hand will rest.

3. Spray the finished drawing with three or four light applications of fixative. By the way, if any clean up is required, use a clean kneaded eraser and take out unwanted charcoal particles and smudges *before* you spray it.

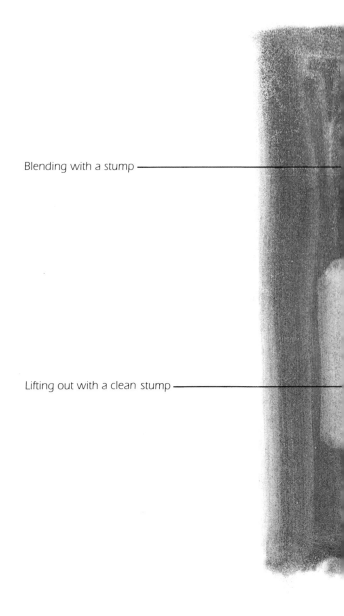

Blending with a stump —————

Lifting out with a clean stump —————

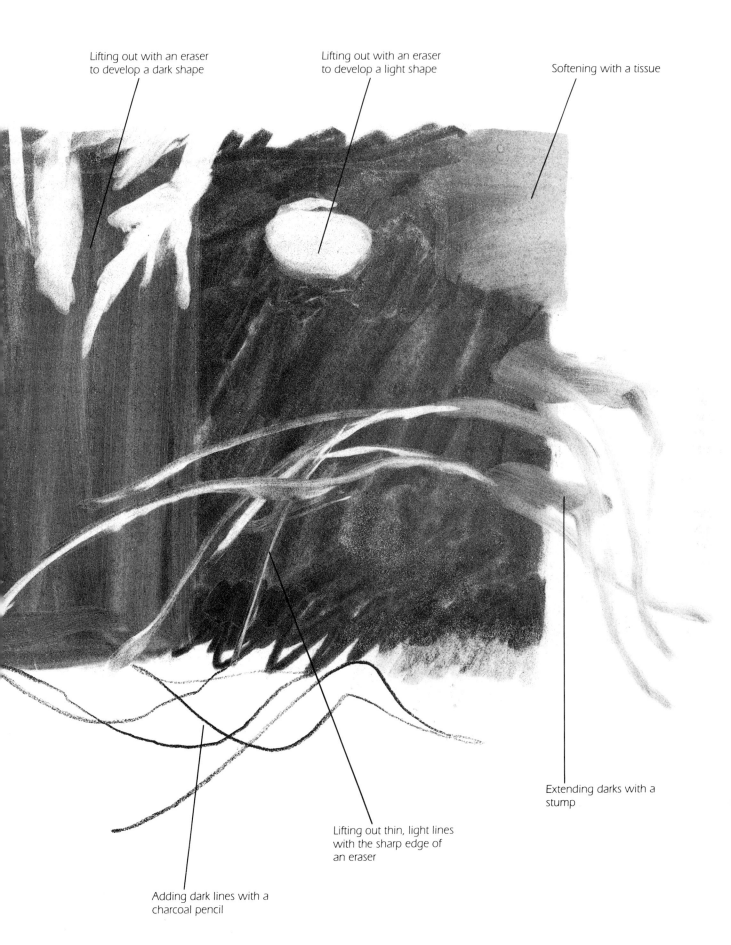

Lifting out with an eraser
to develop a dark shape

Lifting out with an eraser
to develop a light shape

Softening with a tissue

Extending darks with a
stump

Lifting out thin, light lines
with the sharp edge of
an eraser

Adding dark lines with a
charcoal pencil

Lifting a light shape out of a dark area

The following examples show step by step how to model with charcoal. Later you will see how to use the same basic methods to model in color with paints.

1. The first step is to distribute the vine charcoal with a scribbling motion on the surface of the tracing paper. At this point, I'm not concerned where the outer boundaries of the drawing will be. I can always add more charcoal to extend the perimeter of the drawing or I can trim the overall dimensions with my kneaded eraser.

Once I have covered an area I think will be sufficient to contain the dove, I casually smooth the charcoal and blend the individual strokes with the stump.

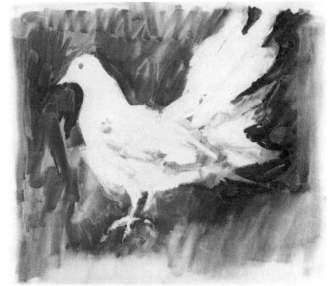

2. Modeling the kneaded eraser to the desired shape, I start lifting the charcoal off the surface of the paper. I began with the dove's head and worked through the main part of the body to the tail feathers. Total accuracy is not necessary since I will have the opportunity to make adjustments later. I continually turn the eraser over so that a clean area is always in contact with the paper surface. This manipulation prevents smearing.

3. Once the dove was roughly described, I made improvements in its outline by altering its silhouette with vine charcoal. I alternated between applying charcoal to the background and lifting out the charcoal with the kneaded eraser.

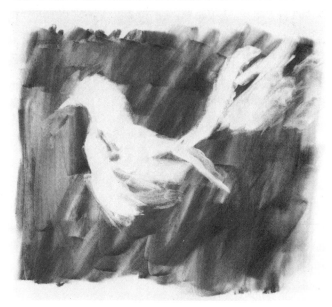

4. When I thought the dove was reasonably portrayed, I added dark counterstrokes to the background. Details were added to the head. Light and dark lines were drawn to indicate feathers. Soft modeling was included to increase the roundness of the body. The legs and feet were not integrated into the body of the bird, so I moved them to a position that seemed more accurate. The final touches were the blurring of edges with stump and tissue. The drawing was sprayed with two or three coats of fixative to protect it.

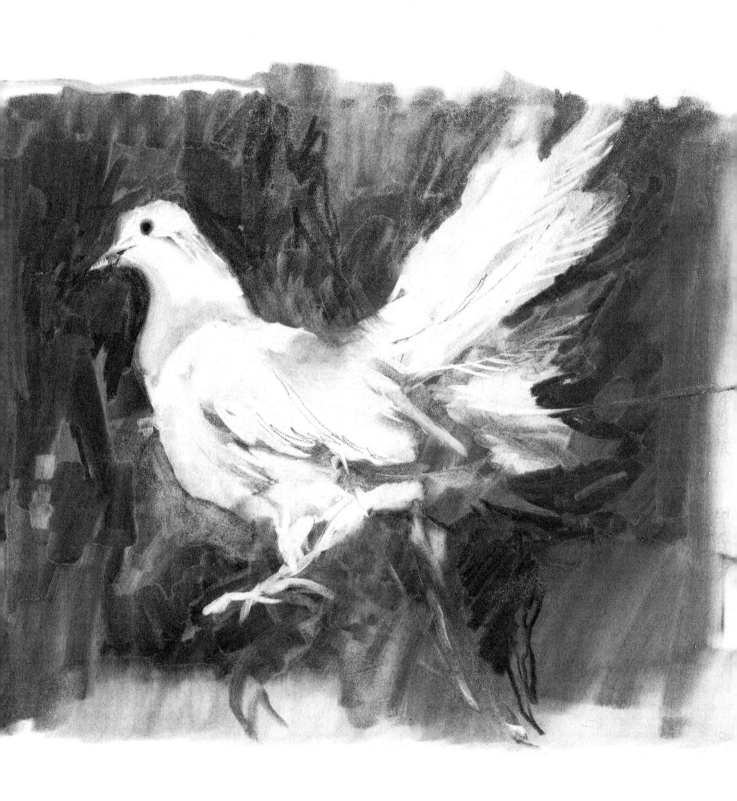

Developing a dark shape against a light background

In the sketch of the dove, most of the bird's development was lifted out with a kneaded eraser. But in this example of tulips, a considerable amount of the description is done with a stump.

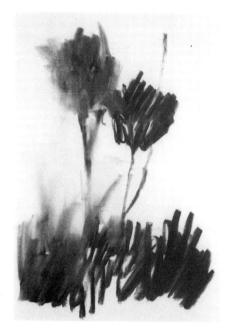

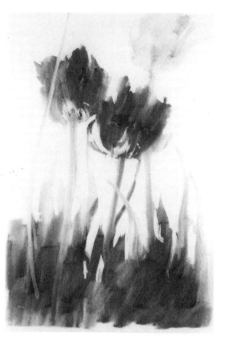

1. I began by sketching the subject very loosely, then smoothed and extended the charcoal with the stump. You can see the blending and softening that resulted in the flower, stem, and grasses on the left.

2. When I had smoothed all of the areas of charcoal, I decided to add another tulip on the right. I did this by picking up charcoal from the dark grass with the stump and drawing the extra stem and flower in a light value.

Working against the edge of my subject with the kneaded eraser, I lifted unwanted areas of charcoal until the outline was a little more accurate. I also drew into the blossoms with the eraser to add shape to their flatness.

3. By squeezing the kneaded eraser into a sharp edge, I drew lines into the flowers to suggest contour and movement. I also lifted lighter shapes out of the grassy area. Thin grasses and stems were drawn in with the stump.

4. I softened the edge of the flowers in a few areas to add variety. By pressing a crumpled tissue to an area, I could get a lighter value. I also blurred the edges with a clean stump to soften the contour. The most delicate linework was done with a charcoal pencil. Then I sprayed the drawing lightly with fixative to prevent it from smearing.

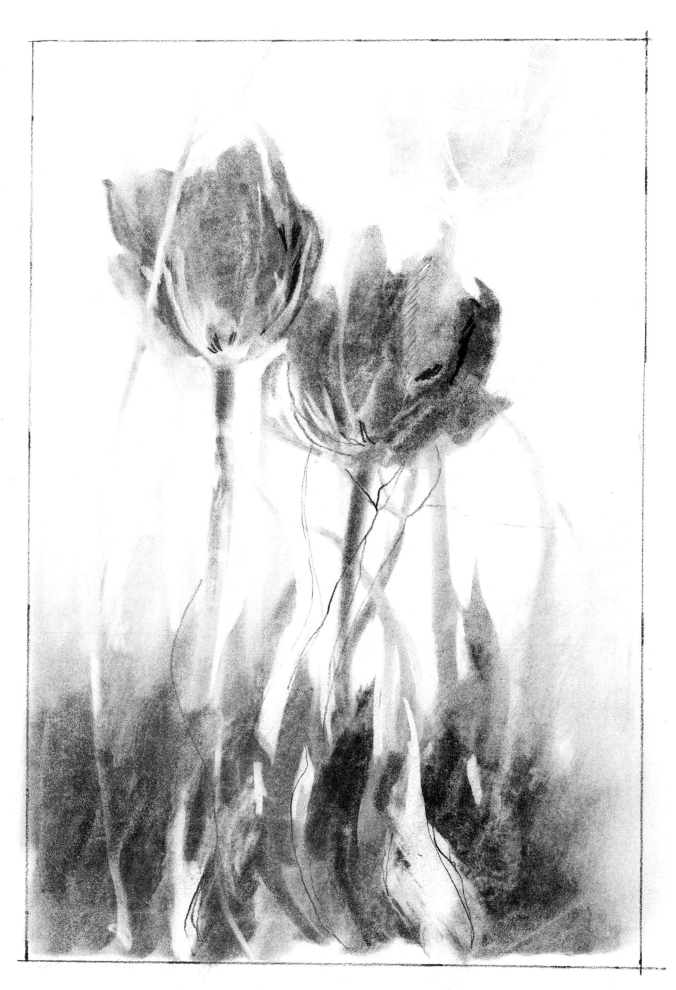

The Evolution of a Painting

Fall River, acrylic on Masonite, 20" × 27" (50.80 × 68.58 cm).

Basic Working Method

This is the way I suggest working. Select any subject that contains a light area encompassed by darks. Develop the design before you begin considering the particulars of your subject. Feel free to change anything you think will add to the effectiveness of the arrangement. When you arrive at the point where you can say, "That's exciting," then you can start working out the details of your subject. Thousands of painters can describe a subject, but only *you* can create your own *original design*. Think about that! Notice how I design and paint a group of ferns.

I worked on a 22″ × 30″ (55.88 × 76.20 cm) piece of 100 percent rag illustration board covered with a heavy coat of acrylic gesso. The gesso was applied with a large flat brush. I didn't try to smooth or sand the surface because I like the effects of painting on a slightly textured ground.

Starting a complex painting without the guidelines of a drawing can be asking for trouble. Beginning a painting before determining general objectives can be self-destructive—but I plead guilty on all counts. The absence of "dos" and "don'ts" and preconceived ideas provides a sense of newness and adventure for me. So I find not knowing what the results are supposed to be infinitely more desirable than the confinement of a plan that may not be workable, or may conclude in predictable results.

I did some thinking before I began to paint. I simplified the scene by mentally eliminating the details until all that remained was a light shape floating on a dark background. Thus the basic value arrangement is a light shape surrounded by middle and dark tones.

1. I covered the board with broad washes of transparent colors in a loose application in order to create obscure value changes, shapes, and edges. I repeated this procedure several times until the board was covered with a 50 to 60 percent value of warm colors.

Darks were then added in order to reveal the general outline of the light area. A loosely described silhouette of the ferns is apparent here, but no effort was made at this point to be precise. I deliberately risked the possibilities of failure as part of the painting process because, as a painting slowly unfolds, I want to be surprised and excited. During these periods of discovery new ways of creating are found.

2. I started the painting by layering one wash of color on top of another until I had covered the entire surface of my paper with a middle value. Then I began to chip away at that value with a darker mixture until I could see a rambling shape of ferns emerging.

I developed the edges and the modeling of the light areas with semiopaque color (color with a little white mixed into it). Slightly darker transparent values were used to quietly suggest movements and shapes in the background as well as to improve the description along the edge of the plants. I painted semiopaque leaves and branches over the darks to give these areas more depth. Then I washed thin glazes of cool colors over areas of the light shape as it moved in and out of the picture so that the strongest contrast was established in the interior of the painting.

3. Before I get into the techniques used to complete the painting, I would like you to notice that the overall arrangement will be changed to some extent as the work evolves to its conclusion.

I continued the modeling of the light ferns by layering *opaque values* on top of each other. Starting with my *darkest* lights, I added increasing amounts of titanium white to my colors until I reached my lightest lights. Then I worked on the background areas. Starting with my middle–value darks, I gradually increased the content of the negative areas until I reached my darkest darks. Repeated alterations in the transparent darks and the opaque lights eventually produced an acceptable arrangement.

4. The final details consisted of middle and light opaque values laid in over the top of the dark negative areas to represent branches, flowers, leaves, shapes, and movement. I applied transparent glazes wherever I thought it necessary to warm up, cool off, or tone down different shapes.

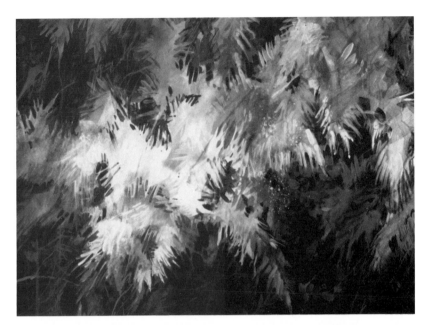

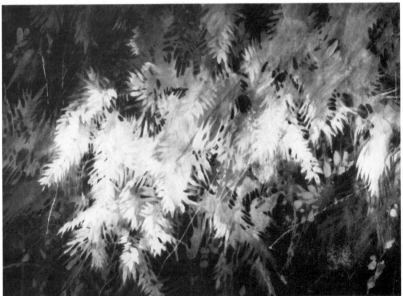

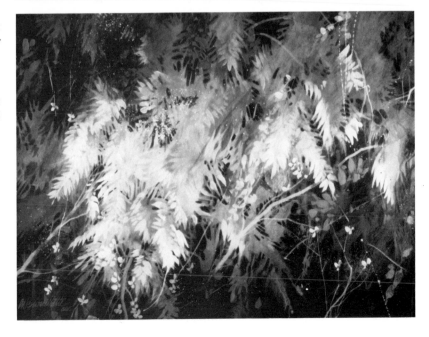

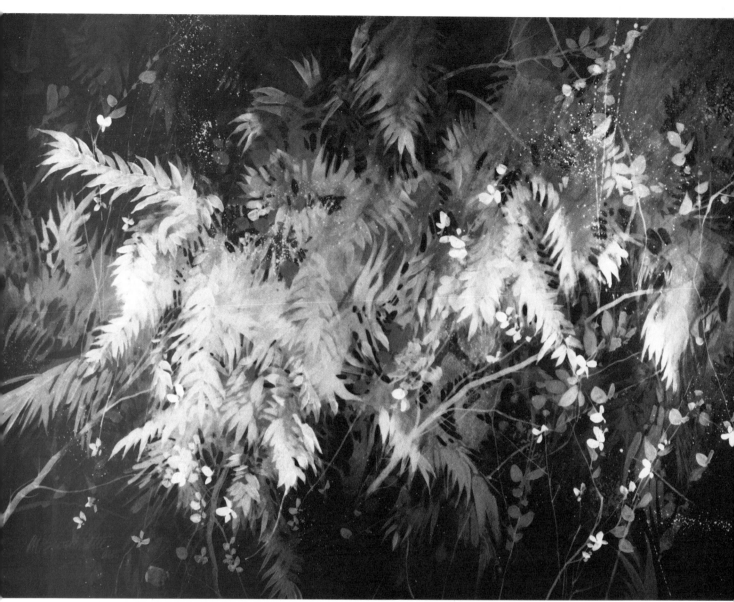

Nature's Garden, acrylic on illustration board, 22" × 30" (55.88 × 76.20). See this painting in full color on pages 2–3.

5. I decided to add a light shape to the upper left to counter the downward movement of the light area. I also lightened the middle–value fern moving out of the painting just left of center at the bottom to securely anchor it to the edge. Then I intensified the cool areas to increase the temperature contrast between the warms and cools. Now the painting looked "right." Any more changes or additions would have upset the harmonious relationships that now existed.

A closer look

I'd like you to take a careful look at what I've done in the preceding steps, much as you would a finished painting hanging in a museum. Get used to looking at art like this—examining artist's paintings for hints as to their techniques.

Incidentally, you'll notice that I don't describe the colors I mix. The reason is that I don't want you to concentrate on color mixtures, just on working from transparent darks to opaque lights—the process rather than the specifics. I also don't want to distract you from the essential values and large shapes I'm using. Instead of thinking "color," think in terms of warm and cool, light and dark, as you review my painting process.

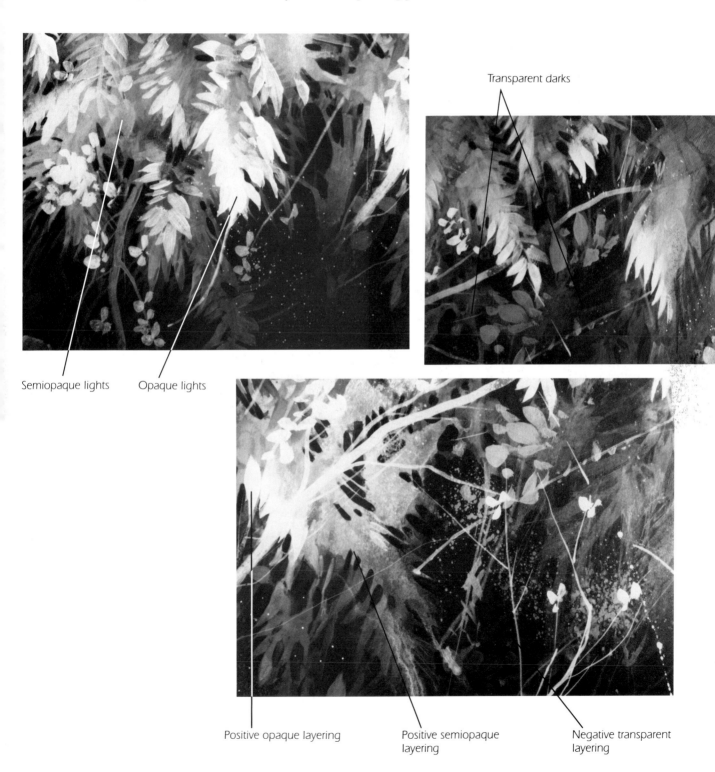

Transparent darks

Semiopaque lights Opaque lights

Positive opaque layering Positive semiopaque layering Negative transparent layering

Working with Contrast

Having watched a simple fern study evolve into a painting, let's see what can be done with a broader subject—a landscape.

The dark land mass and reflections are the strongest visual shape in this scene (see charcoal sketch) because of the light sky and water areas.

That is what would draw the viewer to the painting—the contrast! That is the reason for my emphasis on the dark shape in the drawing. (As you follow the development of this painting, notice the interactions of values. Value, not color, is important.)

1. I began by brushing a wash of neutral cool over the surface of the board to set the tone for an overcast scene. Irregular strokes were used to apply the color. Water was flung and sprayed into the lower areas to create texture in the foreground. When the surface was dry I sketched in the major elements with a darker value of the colors I used in the underpainting. The sky shape was made smaller and more space was added to the foreground. I figured I could use the water and wet sand as a shape device to draw the viewer's eye from the foreground into the interior of the painting.

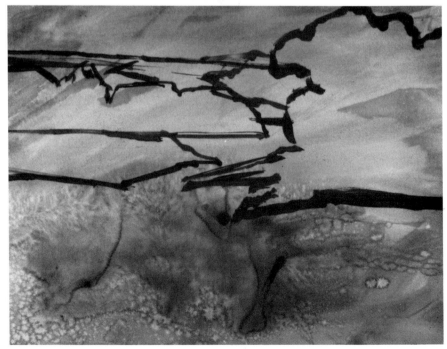

2. With my drawing table in the flat position for control, I laid transparent washes over my sketch with a large flat brush. The colors were loosely applied with little effort made to keep them separated. As the pigment was brushed in, I lifted shapes with a wadded-up paper towel and created texture by spraying the wet surface with water. Finer textures were added by spraying after the surface was dry and then wiping. The close-up lets you see the two kinds of texture clearly.

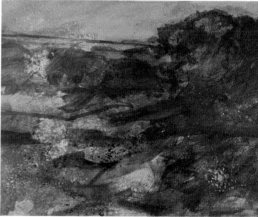

3. The first washes did not result in a dark enough foundation, so I applied a second layer of color in the same manner as previously. I again added more texture by spraying water into the wet washes; I also spattered dark values into the dry surface.

In the close-up, you can see that the combination of washes resulted in a dark suggestive surface into which I could begin to isolate the land area by painting in the sky and foreground with opaque colors. (Titanium white has been added to these mixtures.)

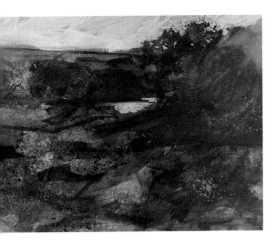

4. With the underlying drawing as my guide, I roughed in the sky with loose, random brushwork.

In the detail at right, where the sky converges with the top of the hill and trees, I avoided painting solid, hard-edged shapes by using dry brush-strokes and then blurring the paint with a paper towel.

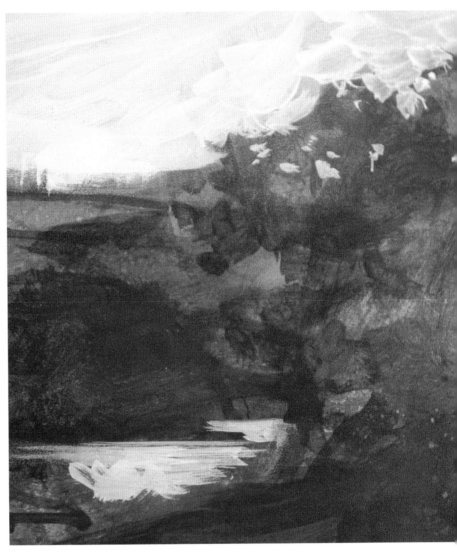

5. As you can see, the basic elements of the value composition have been roughly indicated at this stage. I didn't keep the charcoal sketch in front of me as I was painting because its presence limited my ability to fully respond to the painting as it developed. The similarities between the sketch and painting were sufficient to satisfy me.

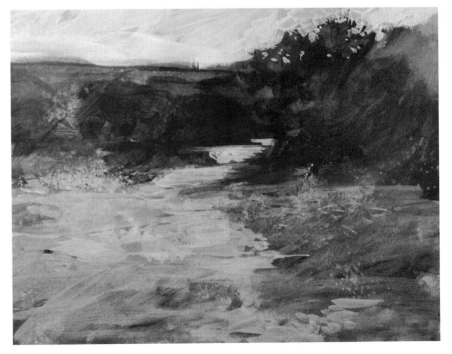

Details. In the distant water and wet low-tide areas, slight variations in value were made to produce a pattern of shapes rather than a flatness that might suggest very little. Notice that in anticipation of the reflection from the trees on the right, I applied a very thin layer of paint over the water area. This was done so that the dark color underneath would show through and suggest the dark value of the reflected trees (below).

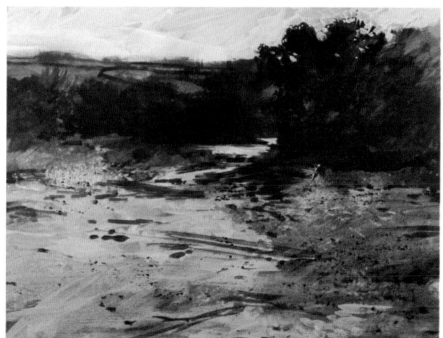

6. Alterations were made in the dark shape with transparent colors. I added the trees at the top of the hill and in the right side of the fields. The outline of the trees running horizontally across the middle ground were described more clearly. Touches and spatters of dark value were painted into the foreground to increase its interest.

A gradual modeling of each area was my next consideration. I began with the sky. Careful attention was paid to the edge quality of the top of the hill and the distant trees. Various applications of brush handling and paint consistency were introduced: dry paint, wet paint, slow and fast brush movement. At times I painted against the dark shape to produce a hard edge. At other times I painted a slight distance from the darks to create a softer edge. The above techniques were not confined to this instance. They were used throughout the painting.

7. The following details show the painting advancing as I worked first into one area, then another. For example, opaque areas were painted into the fields. The upper edge of the middle ground trees was further defined by painting against them negatively. Opaque details were also brushed in to increase their clarity. The stone walls crisscrossing the fields were softened with dry brushstrokes so that they would appear to be behind the trees.

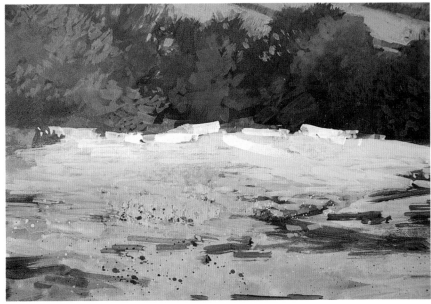

8. A lighter value was painted into the sand area. I started with the lightest value in the right end of the shape, and as I applied the color to the left, I darkened the value so that the sharpest contrast would be in the interior of the painting. The value was also darkened as it moved into the wet sand area. Quick shorthand touches of light color were placed along the upper edge of the sand to suggest boats.

9. I took the liberty of placing another area of sand to the right side of the water to tie both shorelines together.

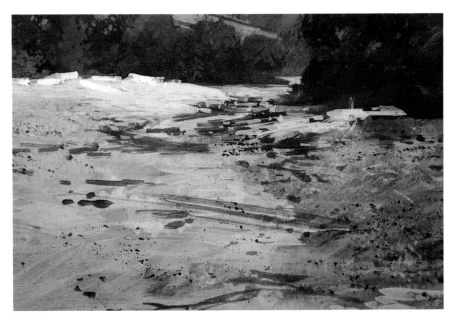

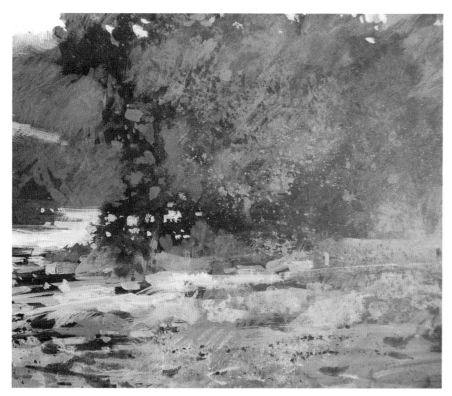

10. Lighter values were painted into the dark groups of trees in the right side of the composition. The strokes were broken up by touching them with a paper towel and spraying them with water. Suggestions of grass and rocks were laid in just below the trees.

11. Now I look over the painting as a whole to see what more is needed. At this point it may look like the painting is complete, but this is the moment when I have the opportunity to make the most of what I have already done. The water and wet sand were lightened with graceful movements from the middle ground to the foreground. The lightest values are nearest the horizon line and are darkened gradually as they progress forward. Once I completed this phase of the painting I toned down, brightened, or increased the color in each area with transparent glazes.

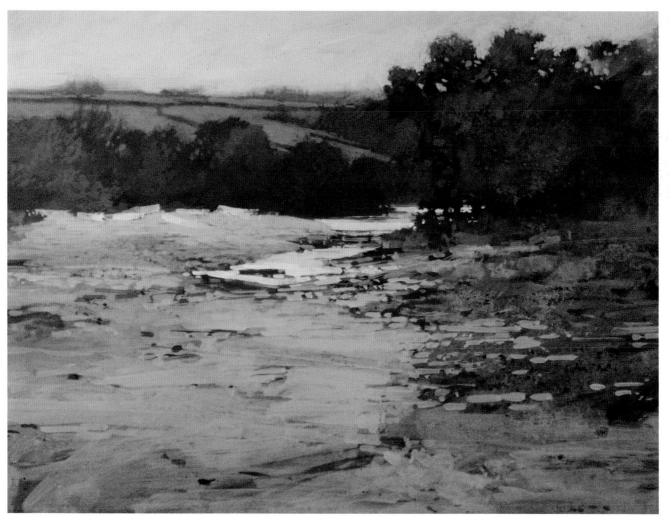

12. Again, I am using details of the painting so you can concentrate on the areas I did work on. The sky seemed to be too flat and out of context with the broken color contained in the rest of the painting, so I fragmented that area with two or three changes of value and placed the lightest area just above the most visible area of water.

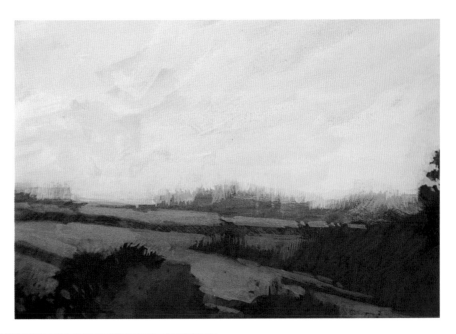

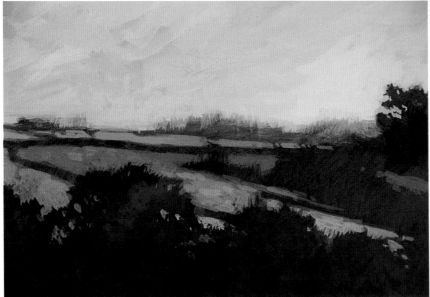

13. Lighter values of broken color were brushed into the background fields. The farthest areas were cooled, the nearest sections were warmed, and the values were mixed lighter as these shapes moved toward the lightest area of water.

14. Here I increased the description of the line of trees with light, warm colors. As I painted into the interior of the composition, the colors were cooled and darkened.

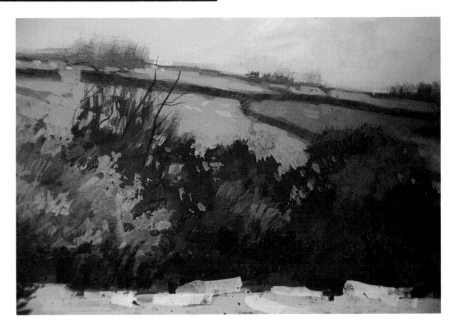

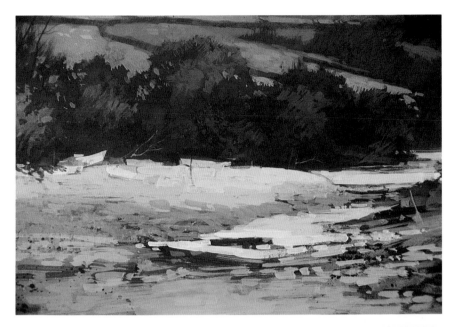

15. Lighter values were added to the boats along with touches of brighter colors to increase their visual interest and to describe them with more certainty. More contrast was needed between the sand area and the lower part of the trees, particularly in the right center area in order to support the center of interest, so I increased their value contrast with transparent darks and opaque lights.

16. The ground area below the trees on the right was defined by modeling the sand and rock areas. Tree trunks were added along with grasses and weeds.

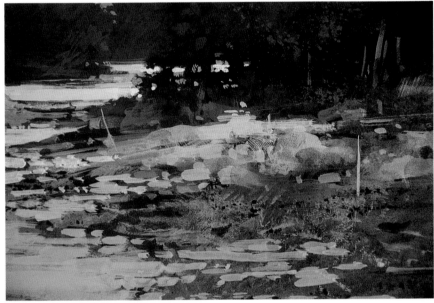

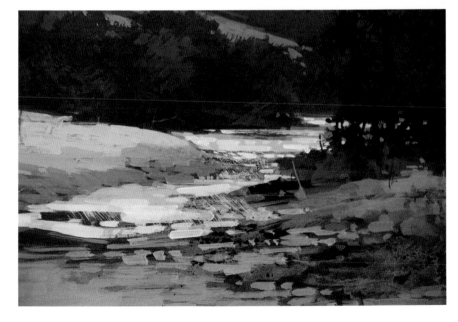

17. I painted back into the water with my lightest lights. As I proceeded forward, I changed the outline of the water, which in turn changed the shape of the shoreline. Dark grasses and tree branches were placed in front of the water.

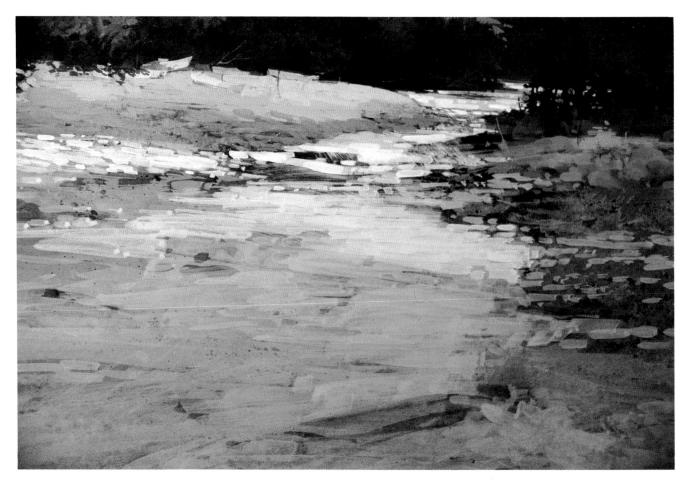

18. The light reflections on the water were brought forward to the foreground area. The opacity of the paint in the immediate foreground was thinned with water so that the darker underpainting shows through. The lightest lights were now contained well within the picture plane. To imply a feeling of distance, the light pattern in the background was intentionally painted in narrow, elongated shapes, and the foreground areas were deepened and designed to move vertically.

19. Light values were applied to the edge of the tree reflection to establish its contour. Darker lights were placed inside the reflection to unify the light and dark areas. The leading edge was lightened with watered-down opaques so that edge strength was again established in the interior of the painting.

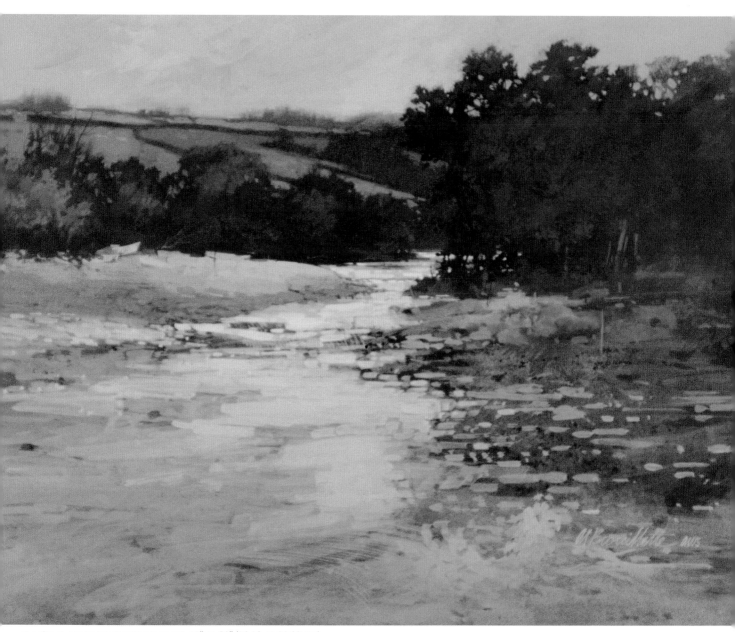

The Cove, acrylic on illustration board, 15" × 20" (38.10 × 50.80 cm).

20. Transparent glazes were brushed into the dark areas where I thought increased color would enhance the finished painting.

A closer look

Very often, watching a painting evolve over a series of stages can distract you from the actual layering process, because there is so much to look at. So let's concentrate on just one area—the water—and see how the layers were gradually formed. Notice how I worked from the broad masses to the details, from solid colors to broken brushstrokes, each time breaking up the area into smaller and more specific details.

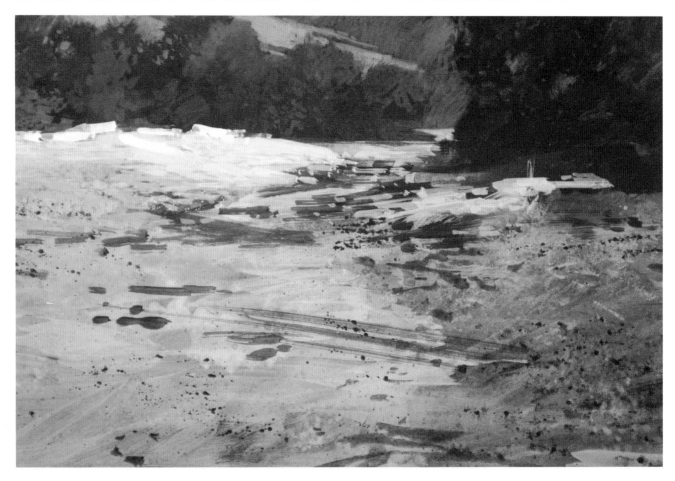

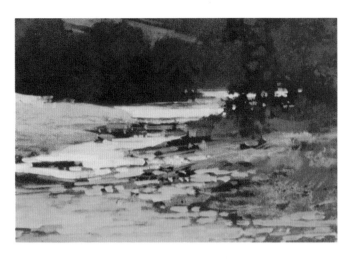

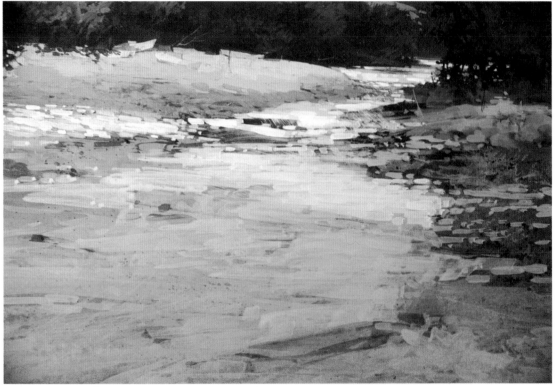

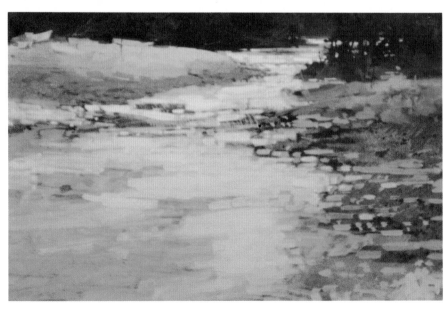

Designing with Values

Value contrast has been a factor in my selection of subjects for as long as I can remember. How many times have I walked a path on a gray day without seeing anything of particular interest, only to return the next day and discover a host of possible subjects to paint. In my own personal case it's usually because "I've seen the light." By that I mean my visual perception was heightened because my walk was on a sunny day. The light and shadows sculpted and illuminated the landscape and created striking arrangements of color and value. This demonstration is the result of a beautiful shining morning.

I covered my canvas with a heavy coat of acrylic gesso. I coated the canvas myself because commercially coated canvases cause the water and paint to crawl, and also because I like a surface that has varied textures to paint on. As the gesso was drying, I textured its surface with a large flat brush. The drier the surface became, the rougher were the textures that resulted.

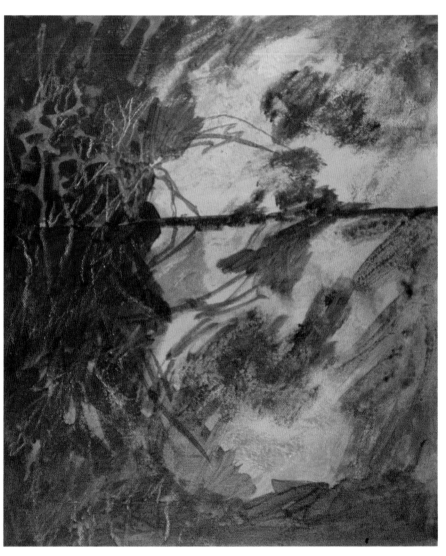

1. When the surface was dry to the touch, I washed a 50 percent value of blue over it. This painting is an autumn scene, and I wanted the blues to interact with the warm ochres, oranges, and reds of the foliage.

2. When the blue wash was dry, I roughed in the location of the major parts of the painting with colors mixed with titanium white. This arrangement will be altered and changed and will evolve during the progress of the painting.

3. With darker transparent mixtures, I painted into the areas left of the large rock at the top and indicated a tangle of trunks and branches by painting the colors behind them. Darker values were added to the water to indicate the water line and describe the outline of the light reflection. Drybrush spatter were worked into the light areas.

4. I wanted to add color to the underpainting before I began to put the light modeling in, so I glazed the surface with reds, greens, and earth tones. Some of these colors would eventually be painted over, but some of them would remain to contribute to the final look.

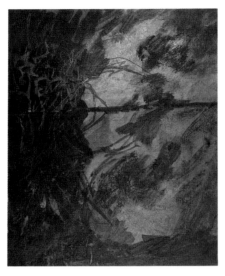
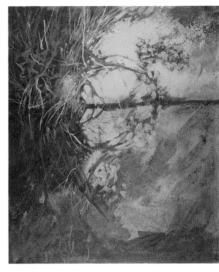

5. Lighter values were used to describe the sunstruck branches and to indicate their reflections in the water. Look closely at the details to see how I worked opaque color over the darks. I also modeled the rock and its reflected image by layering two or three successively lighter values.

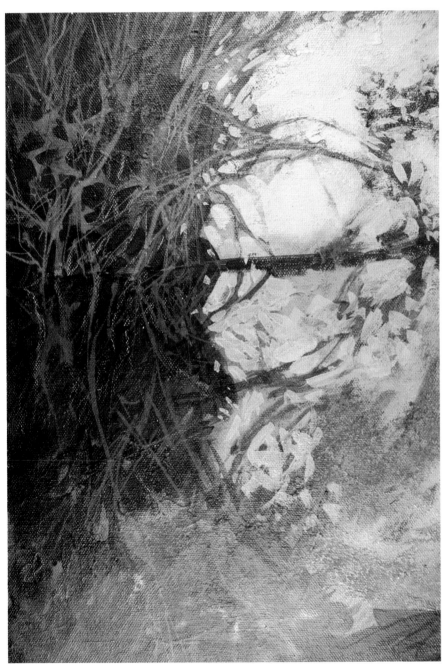

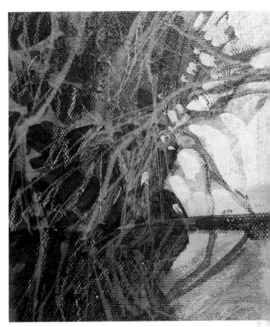

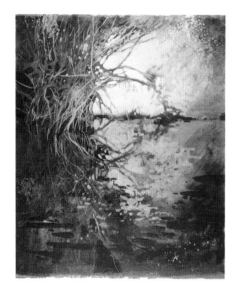

6. Some of the branches were further lightened, and drybrush was used to soften the dark shapes on the face of the rock and at the water line. The water was too busy, so I painted over some of the reflections and changed the outline of the rock. The light areas were then partially modeled.

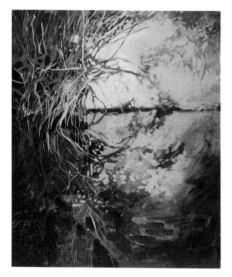

7. I kept moving back and forth between my dark and light areas, trying to increase their contrast. A dark glaze was washed over the water so that the eye focuses on the upper portion of the painting.

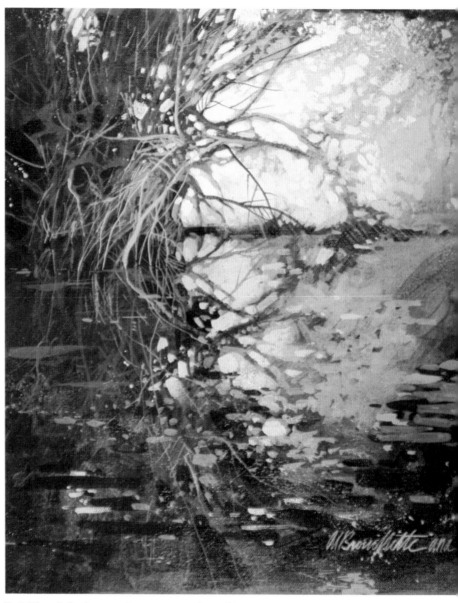

Dark Water Reflections, acrylic on canvas, 14" × 12" (35.56 × 30.48 cm).

8. To complete the painting, I put the lightest values next to the dark branches. As I painted across the rock, I tried to create an interesting light pattern that would heighten the excitement in that area. At this time I indicated more of the rock showing through the branches in an effort to intertwine the dark and light shapes. More light reflections were put into the water and a dark shape was added to the upper right to indicate the top of the rock to further isolate my lightest area. A dark branch was painted across the lightest area of rock, a few more middle and light values were placed in the water, and that was it.

Most of the painting's surface is dark and for good reason. The darks contribute to the brilliance of the lights. Another design factor is the isolation of my lightest areas in the top one-third of the painting, a sure way to get attention where you want it. In this painting, comparisons of value and size contribute to its final effect.

A closer look

Again, as with the previous painting, I'd like you to take a closer look at the final step so you can see how I finished it. Pay particular attention to the layering process. Notice how light is added on top of darks, smaller details tacked on to larger ones, as I gradually work up to a finish. Finishing a painting is merely a matter of tightening up, though. The most important thing is always the initial work, the broad shapes and basic value pattern—the major contrasts and composition. If you don't have that, you don't have a painting!

Building with Lights and Darks

The beautiful and varied outline of this palm silhouetted against the sky caught my attention. A secondary eyecatcher was the sunstruck groupings of fronds with the dark shadow areas as a backdrop. In order to gauge the middle and light values, I decided to paint the darks first. I wanted the darks scattered across the picture plane to give the painting unity, so I decided to cover the entire surface with the darkest values and then define the trees and ground area by painting the sky around them.

I enjoy changing the techniques I use in describing my subject. My approach is determined by what I consider to be the most effective avenue toward achieving what I think is essential for the success of the painting.

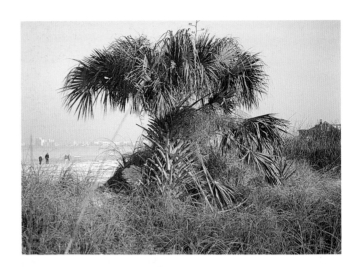

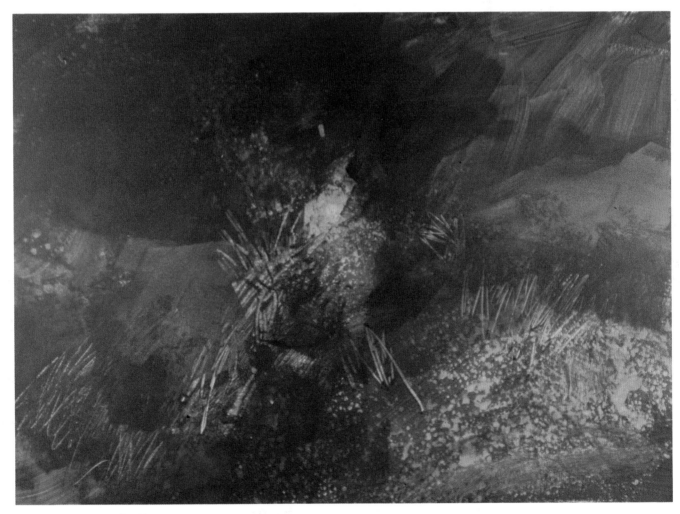

1. I selected dark browns mixed with greens as the dark base to cover the surface of the paper because these colors are a significant part of the subject. Random textures were put in by spraying water, lifting with a paper towel, and scraping through the wet paint with the handle of my brush. Any technique that might accidentally put something *extra* into the painting or trigger my imagination was applied. When the surface was dry, I glazed additional colors into the monochromatic surface.

2. When a preliminary drawing is necessary for the success of my objectives, I use it, even though I think it is somewhat restrictive. In this particular case, an unplanned, searching approach could result in discovering what the eye alone cannot imagine, so I decided to work without a drawing.

Working from the outer edge of my panel, I painted toward the area where I visualized the palm tree and ground area. This process is somewhat like sculpting. I'm *taking away* the nonessential darks by covering them with a mixture of color and titanium white. The darks that remain will be the foundation of my subject.

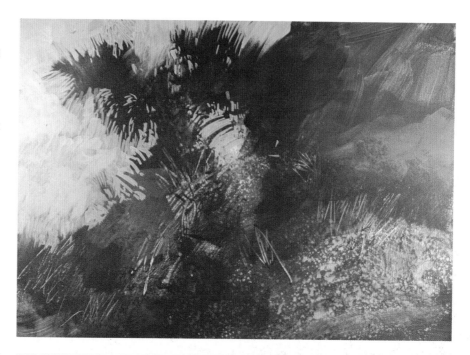

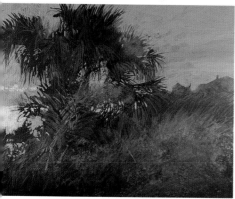

3. The beauty of this method is that I always get another chance to adjust what I have, which I did at this time. I changed the outline of the subject with transparent darks.

In the close-up, you can see that I began to model the palm tree, grass, and beach area with semiopaque mixtures. When those areas were dry, I glazed them to increase their color.

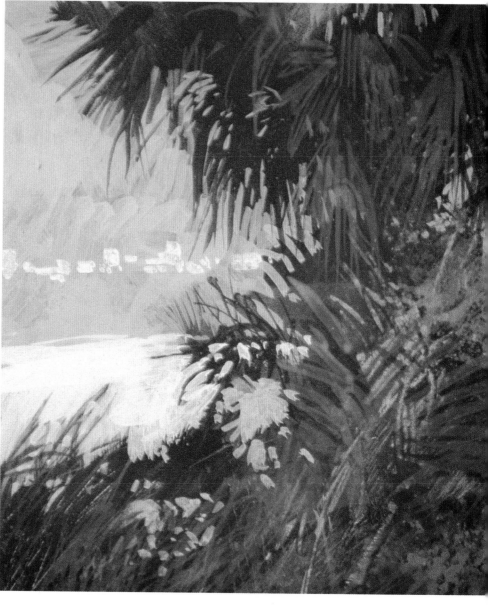

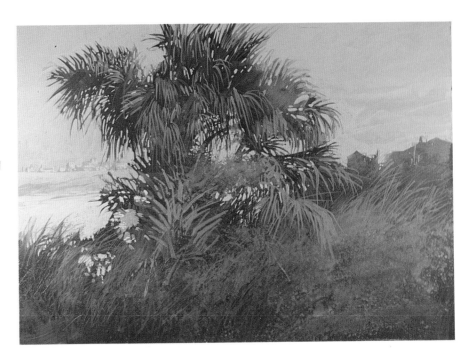

4. The silhouette of the palm tree and ground area was further refined by painting the sky and beach areas a second time.

Detail. My main concern was to improve the beauty of outline of the dark and the light shapes. The effect I wanted was achieved by breaking up the darks with small touches of negative light. More line and spatter were introduced into the ground area to increase its texture.

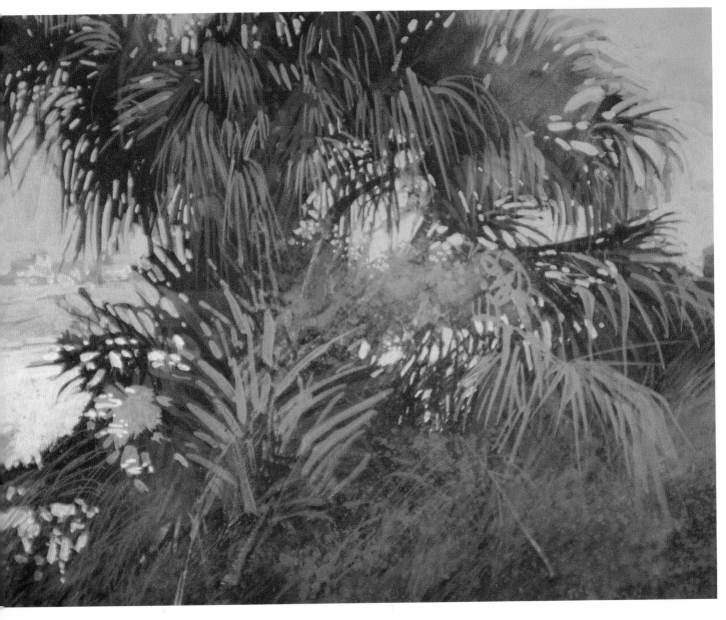

5. The palm leaves needed developing, so I painted into those areas with various middle values. After I had worked the palm fronds for a while, it suddenly dawned on me that the tree was getting very busy. The values were too light for the dark base, so I glazed over those areas with one color to tone the lights down and pull it together. It seemed to work! More grasses were added to the foreground and then glazed. About this time I realized I was having difficulty finding areas to improve, which told me I had better put a mat on my painting and spend a little time considering any changes or additions. My normal tendency is to balance description with suggestion. I think this sort of comparison can be refreshing and can involve the imagination of the viewer in the creative process.

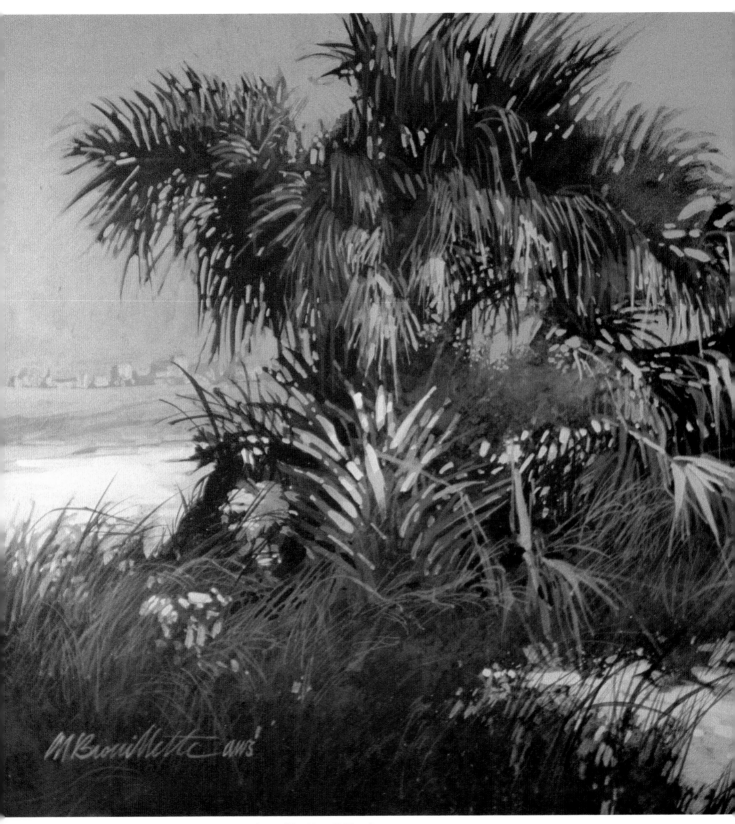

The Palm Tree, acrylic on illustration board, 13″ × 18″ (33.02 × 45.72 cm).

6. I decided to lighten the beach area and darken select portions behind the palm tree and grasses. Sunstruck grasses were added in front of the buildings on the right to push them back into the distance; the foreground was glazed to unify the jumble of lines. I added the sandy area to break up the darks in the immediate foreground.

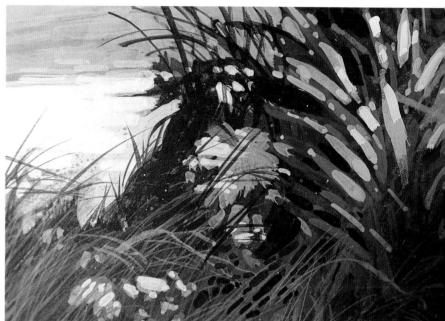

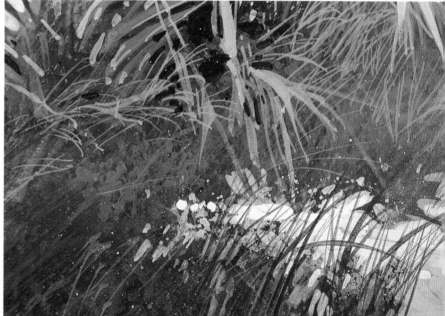

A closer look

Since I work from my own photographs, I should have known better than to paint my middle-value areas as light as I did. Sometimes I paint at odds with what I know from experience and what I suggest to my students. It may be that I get too emotionally involved. That is why the tree "started getting very busy." As I painted from my darks to my lights, I should have *lessened the contrast*. What looks convincing in a photograph does not always work in a painting. I guess that is why we see so many badly executed sunrises and sunsets.

Creating a Free-Form Value Pattern

I've developed a habit of walking about with my eyes focused on the ground. It started in 1975 with my first discovery of what was to become a recurring theme in my painting, the downward, close-up views of nature. When I found the first interesting fragment and bent over for a closer look, its objectivity seemed to fade into an arrangement of shape and value. As a result, I began the painting as I saw it, abstractly. The sea grapes affected me in this way, so the painting began as an exercise in creating a free-form pattern of contrasting values. No preliminary drawing was necessary because corrections and alterations are easily made with opaque colors.

1. I began brushing in the color from the top, with the intention of enlarging it to its final configuration. Random textures were added to the wet paint by laying wax paper and plastic wrap on it, and then lifting it off. Lines were scraped into the damp paint with the handle of my brush.

2. I enlarged the dark shape until it dominated the picture's surface. Up to this point the arrangement was far from satisfactory, and the value was too light to contribute to the strong contrast I think is necessary between the dark and light areas.

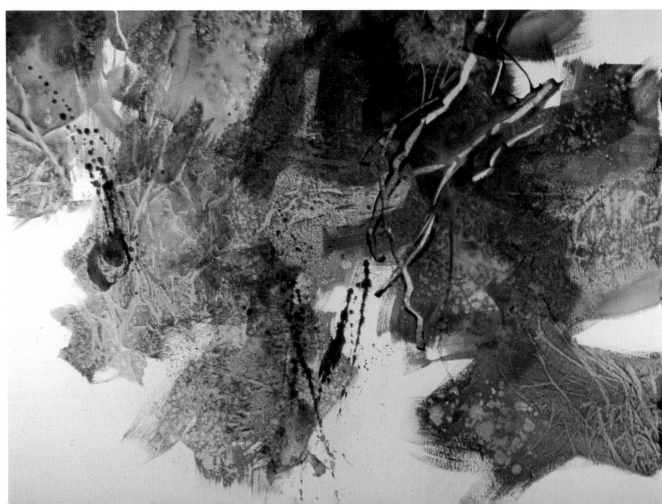

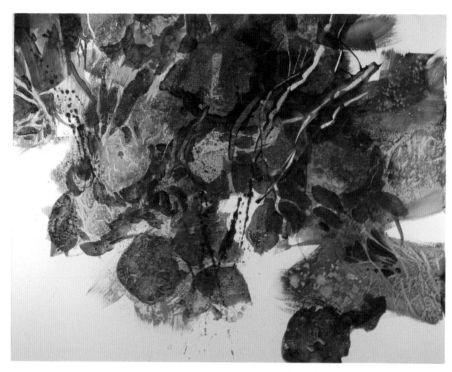

3. A darker value was layered over the positive shape and more texture and lines were put in. As I was painting this layer, I loosely suggested outlines of grape leaves. I'm getting ahead of myself a little because the negative shapes are hardly adequate.

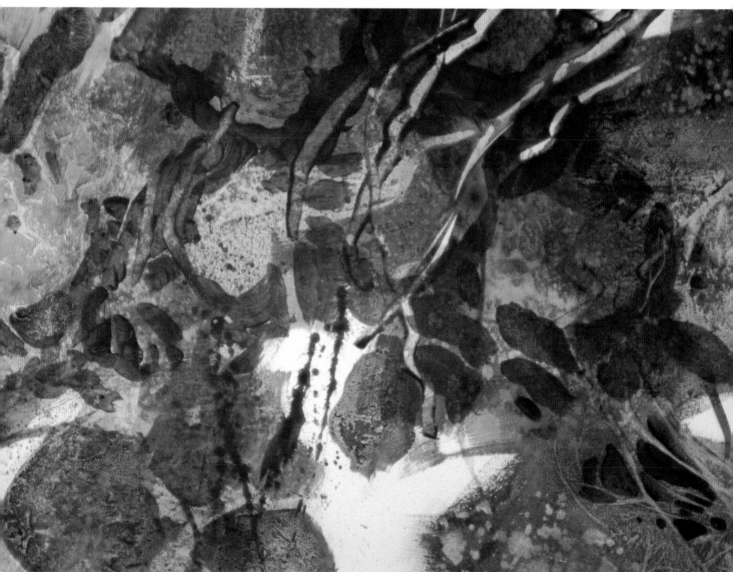

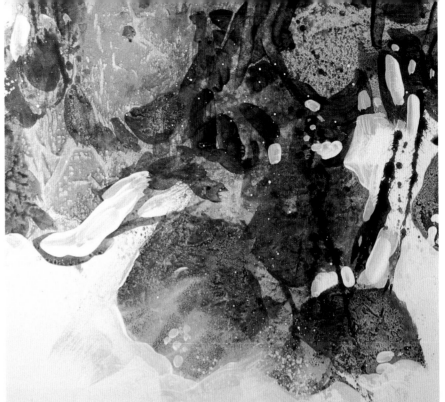

4. With quick strokes of acrylic gesso, I worked around and into the dark shape to improve it as well as the light shape. Alterations were made in the outline of the positive area, and the negative lights were integrated into it. Gesso was rubbed across some of the darks to lighten them.

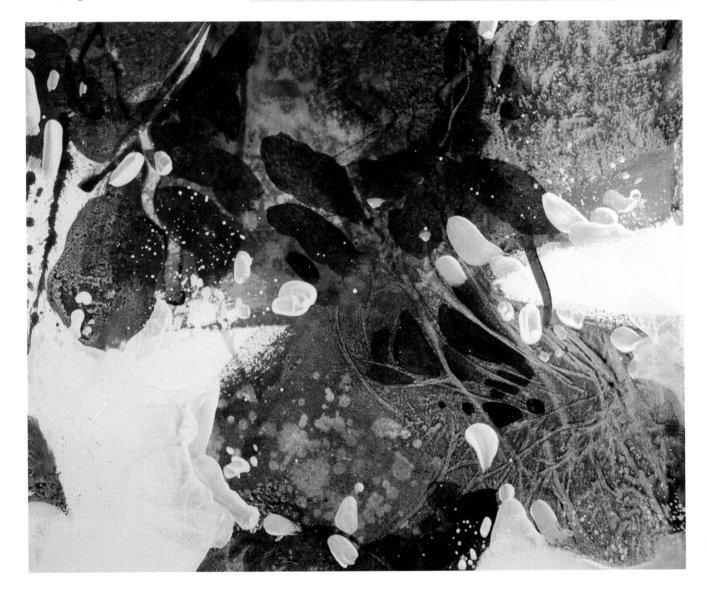

5. As of now, there is limited color in the painting, so I glazed over the darks. For glazing I used small amounts of color with plenty of water. Ultramarine blue was washed over the outer areas. As I glazed toward the interior I used burnt sienna, raw sienna, yellow ochre, Acra violet, cadmium red light, cadmium orange, and Turner's yellow in that sequence. If the resultant color was not sufficient, I could allow the surface to dry, and then repeat the process.

6. The progress of the painting was largely experimental up till now. The emphasis in my approach had to change if I was to be successful when describing my subject. This is when craftsmanship becomes very important. Many more discoveries were made along the way, but my intention was to move as directly as possible toward the resolution of the painting. The development of the leaves and stems came first. Details were added by direct painting with a brush and with spatter flung from the brush. Areas behind the leaves were darkened with transparent colors. Where a leaf or stem was silhouetted against the sand, alterations were made with gesso.

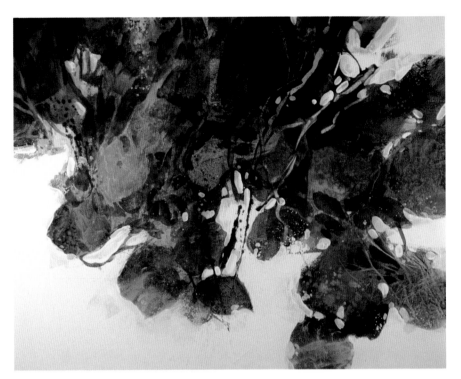

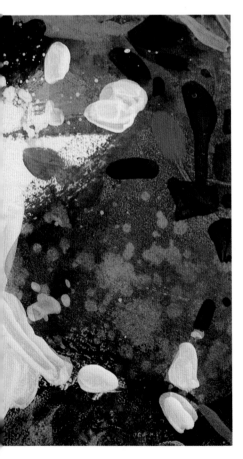

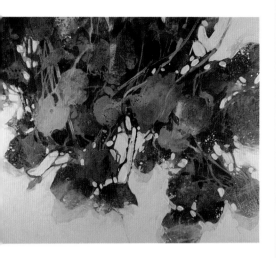

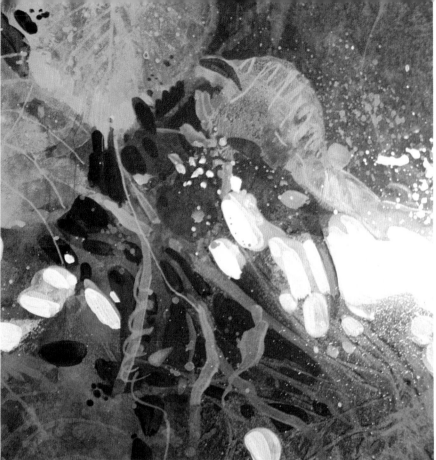

8. In order to model the sand, I needed to darken those areas so I washed a blue over them. This color would represent the contours of the ground and shadows cast by the leaves and stems. When the wash was dry I painted the sunlit areas and left the blue as cast shadows and land contours. Opaque mixtures were used to do this. As I was painting the sand, I made numerous changes in the dark arrangement. Additional colors, shapes, and textures were worked into the leaves with spatter, dry brush, and by rubbing pigment into the surface with my fingers and drawing linear descriptions with a brush. The delineation in the areas around the leaves continued with successive layers of ever-increasing darks. Those areas of the stems that were exposed to the sun were lightened. When the painting was almost completed I glazed again, using the same color sequence as I had earlier.

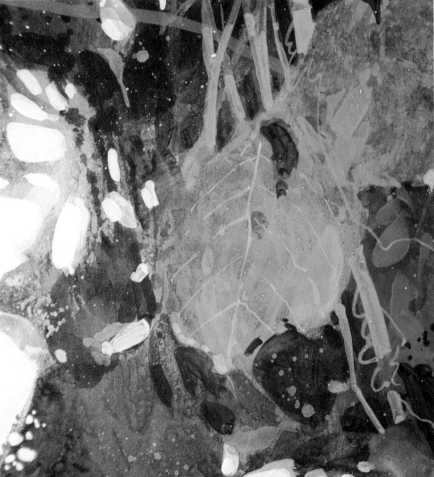

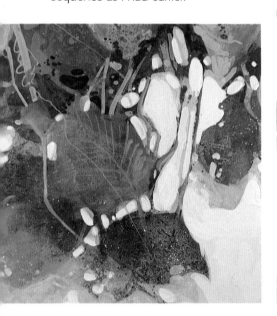

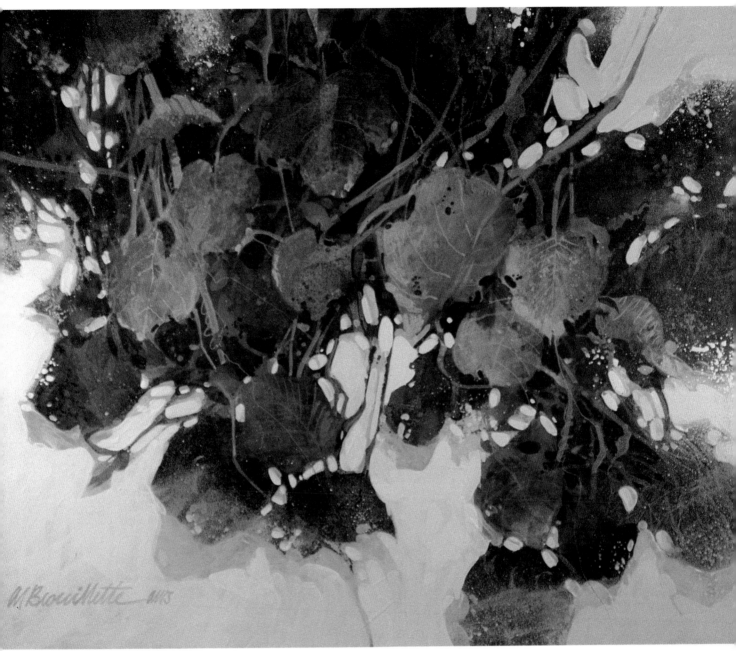

Sea Grapes, acrylic on illustration board, 15" × 19" (38.10 × 48.26 cm).

9. Lighter values were painted into the negative sand areas to increase the contrast and to bring out the cast shadows. The lightest sand is around the cluster of leaves to the right of center to bring them into focus as the dominant area.

A closer look

Students ask me how they can grow as an artist, find their own style and be original. Many of them, wanting quick results, are disappointed in my reply: "Paint, paint, and paint some more." Being "original" requires a willingness to act in response to an impulse. The reaction is instantaneous and emotional. The result is a revelation to the viewer *and to the artist who did it*.

An understanding will become apparent from the practice of painting. That realization is a readiness to fail in order to succeed. It can make your task more pleasant and, in the long run, more successful.

Painting Flowers as Abstract Designs

I've heard artists say, "You can't paint what you don't know." Similarly, some portrait painters have said, "It's impossible to paint someone unless you have associated with that person quite a while." And one of my painting friends proclaimed, "You can't paint the ocean unless you live by it." These statements are going to come as quite a shock for artists who have painted gods, angels, or abstracts! But the opinions of others won't help you much when you are faced with your own artistic reality. And this is what I am confronted with when I paint.

Spring in Texas usually tempts me into doing a series of flower paintings. Even though I realize I know very little about flowers, it doesn't stop me. They can be large or small, growing in fields or in pots on a windowsill, with colors as numerous as those reflected from a prism. I see them as forms, patterns, and colors, not as irises or daisies or roses.

1. Working without a preliminary drawing but looking at two Polaroids of irises, I began to wash color onto my surface. After covering a portion of the board, I removed the paint with a wet paper towel in the area where I wanted the first flower. The lift-out area was further defined by painting around it with color. I used the same techniques for the placement of the second flower.

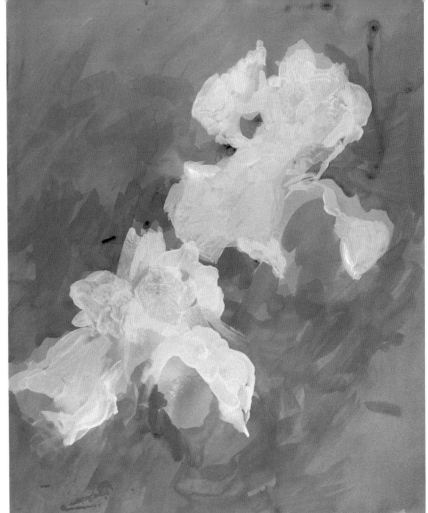

2. I didn't like the arrangement that resulted because both flowers were equidistant from the painting's edge. I moved the bottom flower higher and to the left to see if it would create a better design.

3. The changes did help, but the outline of the irises seemed unimaginative. I went ahead and changed their outlines with some semiopaque color. At this point it looked like the background was too busy, so I laid another wash over it to quiet it down.

4. I'm thinking about adding the stems, buds, and leaves, but the background is still too aggressive. That problem needed to be resolved before I went any further. I decided to paint it with a color mixed with white to cover the numerous brushstrokes. It worked! Now the irises assumed their proper importance.

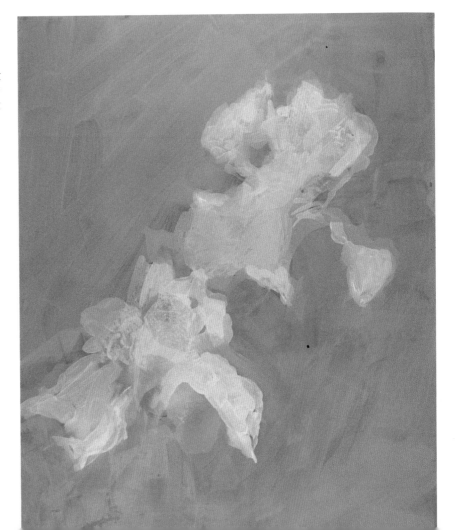

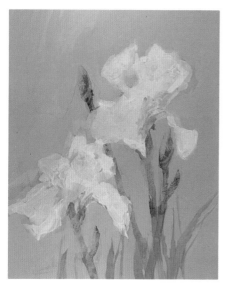
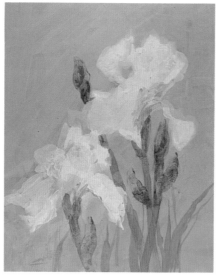
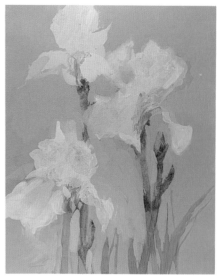

5. I went ahead and painted in the stems, buds, and leaves. I was careful to add the background colors into their mixtures so the colors would work together. I increased the modeling in the petals with more changes of value.

6. I altered all of the subject matter's outlines by adding another semiopaque layer to the background. As I painted, I trimmed some shapes by painting against them. I also dry brushed color into the stems, buds, and leaves.

7. The placement of the flowers still bothered me. Their arrangement seemed too predictable. Another blossom would resolve the situation so I painted one just to the left of center at the top. I moved the bottom flower farther to the left and extended it off the picture's surface.

8. I returned to modeling the flowers with changing values. I altered any shape I thought was unsatisfactory by extending its shape or diminishing its shape by painting the opaque background color into it.

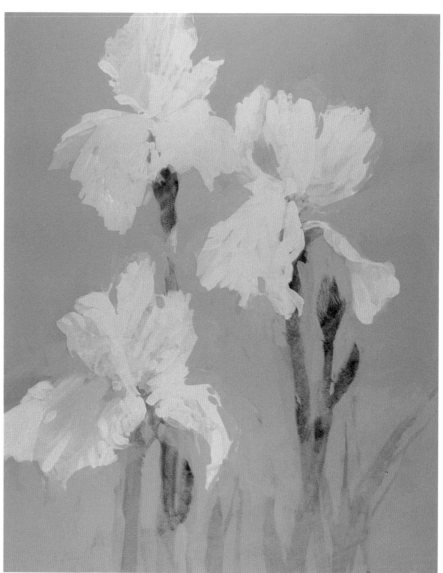

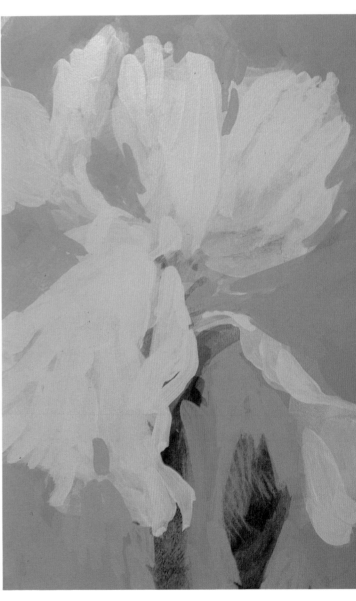

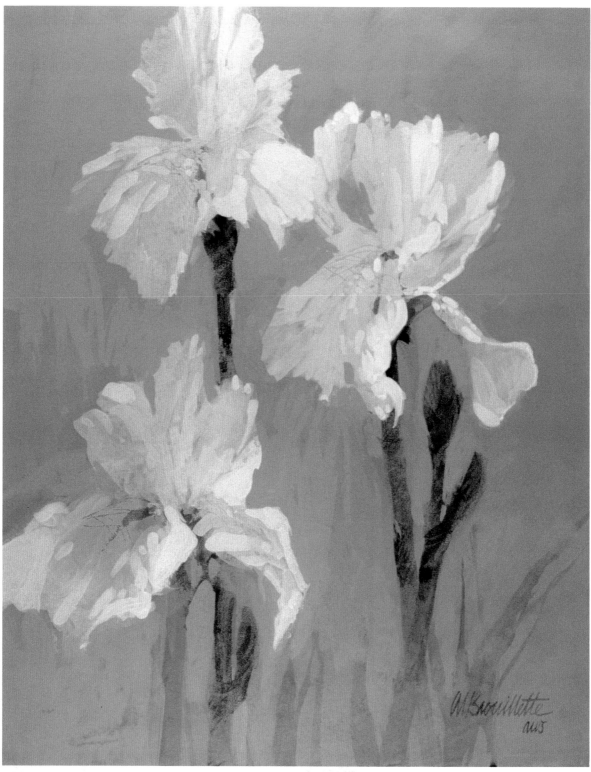

White Irises, acrylic on illustration board, 16" × 13" (40.64 × 33.02 cm).

9. The description of the flowers continued with the addition of colorful details and surface forms on the petals. Changes of value and color were also used to define the stems and buds further.

The lightest lights and final touches concluded the painting, except for a couple of necessary adjustments. The alterations were needed to establish a dominant area. The background was lightened behind the flowers on the left, and they were glazed to darken their value. The iris on the right was left lightest with the darkest background.

A closer look

Notice how I worked within each petal, adding more and more details. I actually saw little of this in the flower—most of it came from my own imagination and design sense, triggered and inspired by the flowers. But I worked from within myself. I did not copy them.

How much information does one have to have before painting *any* subject? I think that would differ with each artist. My informational needs are usually minimal as long as I can satisfy my personal requirements as an artist. I'll conclude by offering a quote from Georgia O'Keeffe that directly relates to my own artistic philosophy: "Nothing is less real than realism."

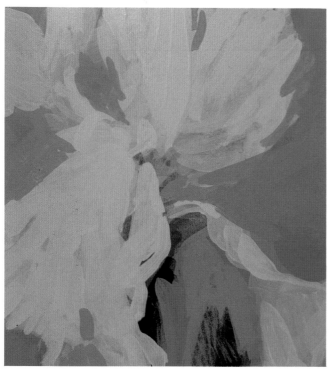 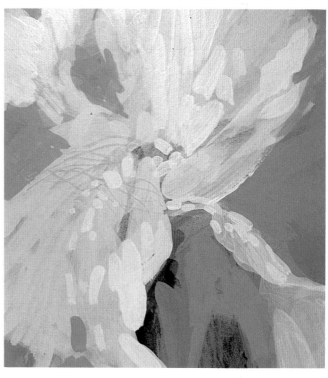

Applying Abstract Design Lessons to a Portrait

It was a very cold afternoon in Charleston when I met a lady selling dried flower arrangements. She was open and friendly and, on my suggestion, allowed me to take a few pictures of her. I liked the slides that resulted and decided to do a painting.

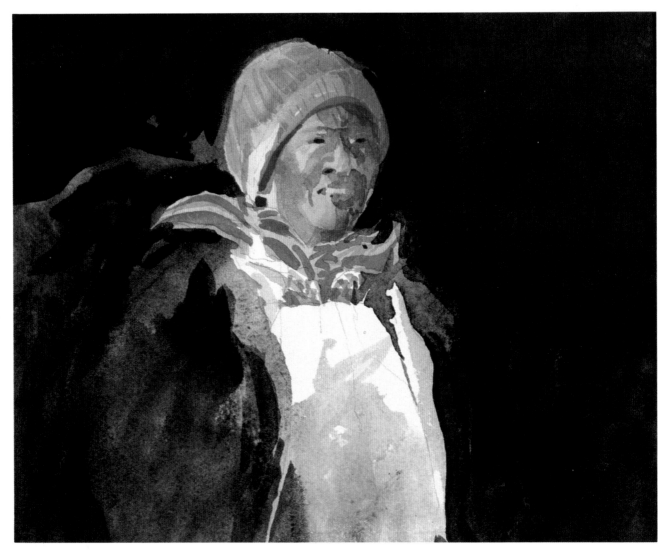

1. I worked out my ideas in a small sketch. The warm colors of the woman's clothing appeared to come forward and the cool background receded. The figure was described and dominated the picture plane while the negative space around the figure was flat and got less attention. The numerous light and middle values against the dark background control the picture's surface.

2. I began the painting with a complete pencil drawing as my guide to the positive and negative relationships and then started to block in the background.

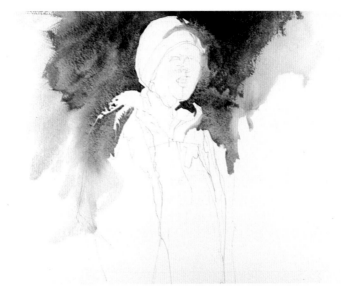

3. As I painted the background around the figure, I also modeled the shadow areas of the wool cap, face, and apron with diluted color. The jacket's outline was not indicated at this time but would be defined during a later stage. The darkness of the cast shadow on the upper part of the apron and the modeling just below it bothered me so that I made a mental note to change them.

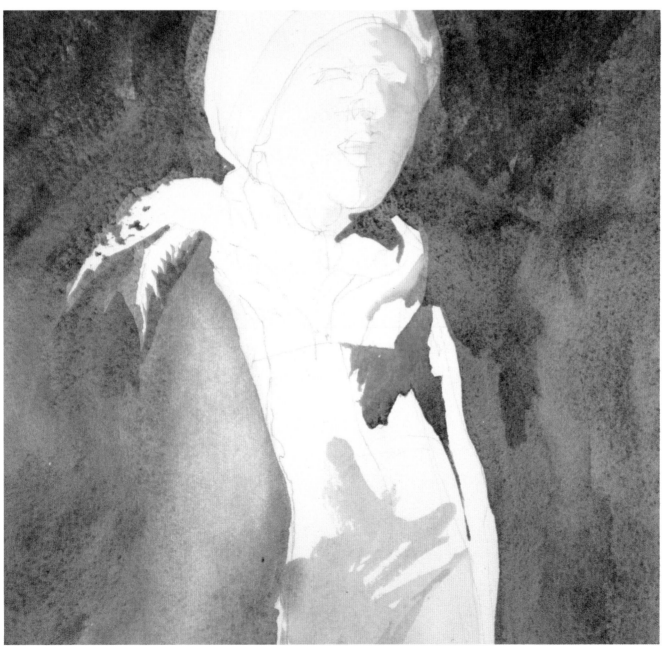

4. I started to model the cap and face with a continuous wash. I was applying my lightest values so I avoided creating hard edges. I quickly suggested some modeling in the scarf and color patterns in the shirt. I layered a second wash over the background to darken and smooth it. Small changes were made along the edge of the light area. The second wash was painted up to the outline of the jacket to define its edge.

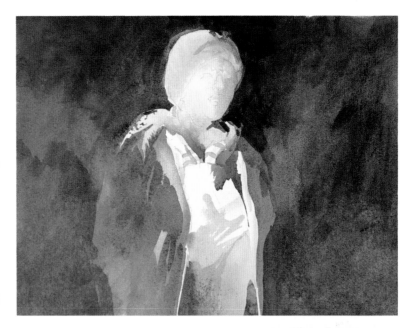

5. Now that my lightest values were in place, I applied my middle values. I intensified the shadow areas in the cap and suggested the knit pattern and texture. Starting with the forehead, I continued to describe the eye sockets, nose, mouth, chin, and neck. I extended that wash into the shadows on the right side of the face. Highlights were suggested by painting around them. While these areas were still wet I dropped a slightly darker value into the face, just to the right of center to indicate the turning of the facial plane away from the light.

Up to this point very little work had been done on the scarf and shirt. The color and patterns were painted in as an impression of the actual items. More effort toward accuracy was needed in describing the folds. The patterns had to conform to the shape of the body.

The shadows on the apron still seemed too dark, so I lightened their value by scrubbing lightly into them with a toothbrush and water until I had removed some of the pigment.

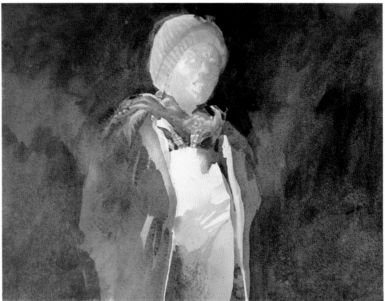

6. Darker values came next so I continued modeling each area as I moved toward the completion of the painting. The knit cap seemed to be sticking out too far on the right side so I trimmed it down a little so that it would appear to be curling around the head. Darker values were washed into the right side of the cap to increase the head's roundness, and more intense shadows were painted into the scarf.

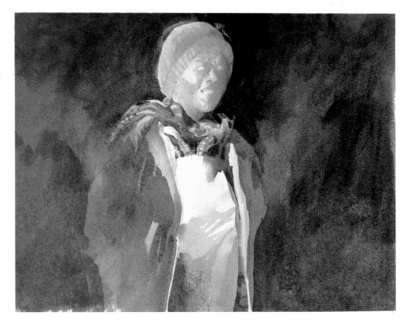

7. The background still had too many changes of value and seemed to detract from the figure, so to quiet it down I applied a third wash to it. The outline of the left side of the head was changed by painting over the cap in that area. A broken edge was added to suggest a bulky knitted material. Another skin value was used to model the darks in the face, and further attention was given to cast shadows on the face from the hat, on the left side of the nose from the brow, and to the left of the nose from the cheek.

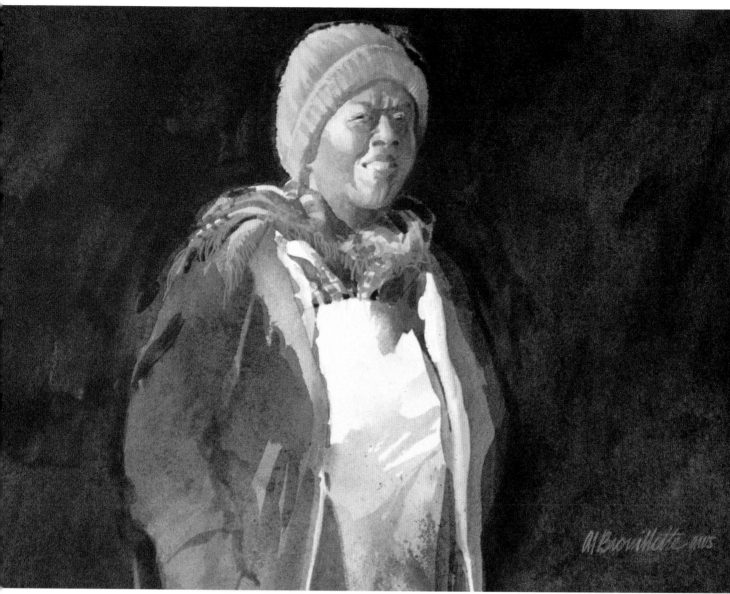

Charleston Street Vendor, acrylic on watercolor paper, 11" × 15½" (27.94 × 39.37 cm).

8. I added titanium white to my color mixes for the finishing touches. Highlights were drybrushed into the cap along with cool blues in the shadow areas. Cools were painted along the right edge of the face. The fringe on the scarf was completed with opaques. Finally, cool transparent glazes were added to the right side of the head and warm notes were glazed into the background.

A closer look

Each of us seems to be influenced by different visual stimuli. When I first began to paint, many of my works incorporated sun-drenched white buildings with dark windows and open doors showing dark interiors. Later, the emphasis seemed to shift to winter landscapes, and after that to close-up arrangements of vegetation on a light ground area. Through it all, it seems that my subjects have changed, but not my reasons for painting them. Such is the case with *Charleston Street Vendor.* All of the above contain the element of contrast, a major factor in design.

Applying Design Ideas to Architectural Subjects

Caution seems to be my standard response when I get involved with painting buildings, even though I rarely react like this when I am painting other subjects. My inclination to architectural exactitude seemed to eliminate most possibilities of exploration and discovery until I made a breakthrough and began to interpret man-made objects in the same way I did landscapes, figures, and nature. That is, I develop shapes, values, and colors that happen to suggest buildings.

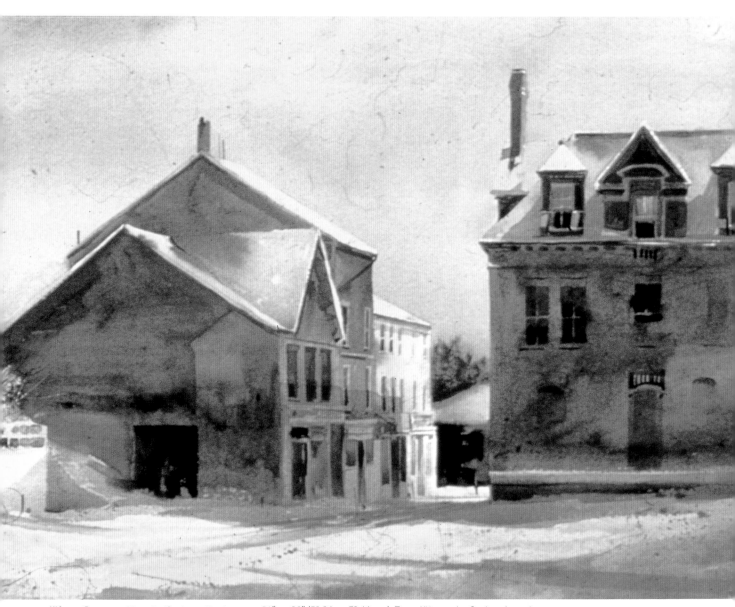

Winter Comes to New Bedford, acrylic on paper, 21″ × 29″ (53.34 × 73.66 cm). Texas Watercolor Society Award.

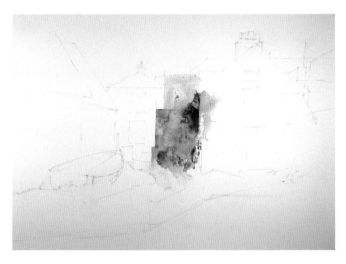

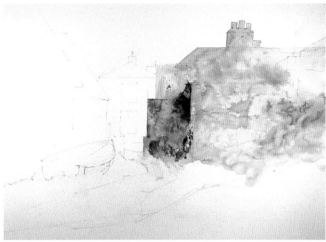

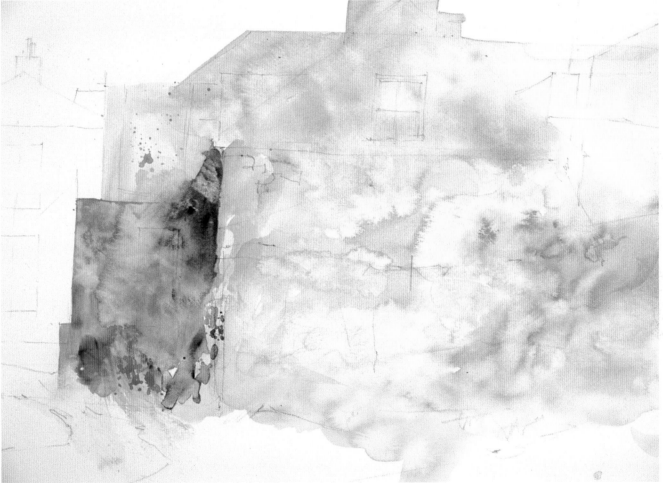

1–3. Changes and alterations are difficult in a transparent acyrlic water-color. Once the pigment is completely dry it is almost impossible to lift. That is why the placement of the large elements needed to be indicated with a pencil drawing. Many of the details that were not essential for the success of the painting were left out. This process helped personalize the work.

Starting in the left center of the composition, I began to lay in the underpainting with a light wash that eventually covered the buildings on the right. Various textures were suggested by lifting and spraying the wet pigment. Specific architectural details were not indicated at this time. I prefer to start with simplicity and stay with it as long as I think it contributes to the effect I want. It is so much easier for me to add what definition I think is necessary rather than trying to remove nonessential details later.

4. Light values were washed over the building on the left. The colors were a mixture of earth tones that were cooled as I worked toward the uppermost parts of the roof. I wanted that area to blend with the cool of the sky so that the viewer would focus at ground level. To further my plan, the roof was rendered smoothly and mottled broken color was used on the lower wall sections. The boat was white so I painted around most of it.

5. The sky was brushed in with a neutral blue wash that was painted around the background structure but allowed to extend into the upper areas of the foreground buildings. The house I painted around was tinted with a very light earth tone, and the same tone was placed over the boat. Various layers of cool greens and earth tones were loosely brushed into the ground area, then textured by spraying with water. Brushwork to suggest grass was added, followed by more color spattered into wet and partially dry sections to produce more texture.

I've seen a lot of students get discouraged and give up on their painting at this point. What I now have is quite messy and lacks content, but I have learned through experience that patience and continued work can produce dramatic changes for the better. Painting a picture is similar to living a life. We struggle through the rough times so that we can enjoy the happy moments—we don't give up.

6. A continuous wash from the chimney to the eave of the roof was placed on the light building in the background, and the window panes were loosely described with various middle and dark values. Some of the dark shapes, trashcans, etc. were roughed into the alley and carefully painted around the front of the boat. The boat is important as a device to move the eye down the alley to the light house, which will be the visual center of interest.

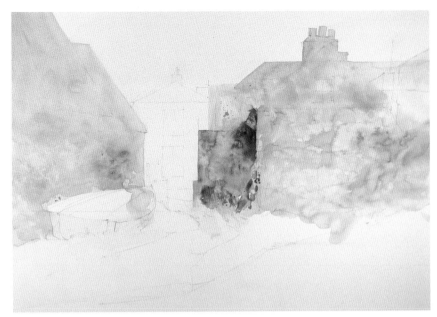

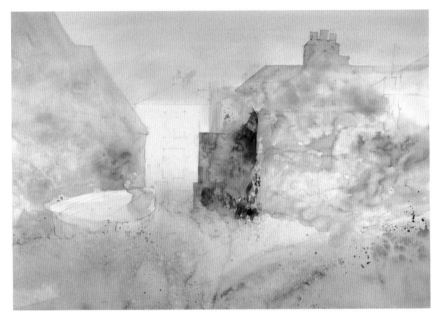

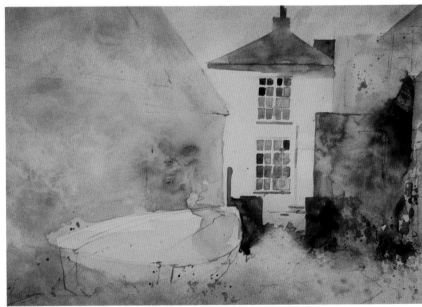

7. Various line work was drawn into the roof of the structure on the left to indicate separate tiles, and a variety of shapes, sizes, and values were painted into the wall to imply stonework. A window was added above and to the left of the boat. A stack of netting, traps, and other fishing paraphernalia was suggested. Contour washes and descriptive details were added to the boat.

8. I continued with my middle darks and modeled the chimney above the the peak of the right-hand buildings and washed a darker value over the face of that structure. Fine spatter was applied to the wet paint to increase the spotting. The darks in the shadow side of the building were broken up to indicate cast shadows, a window, and materials stacked in the dark corner. These results were accomplished by painting a darker value around the details I wanted described. Missing tiles and openings in the slanted roof were painted in.

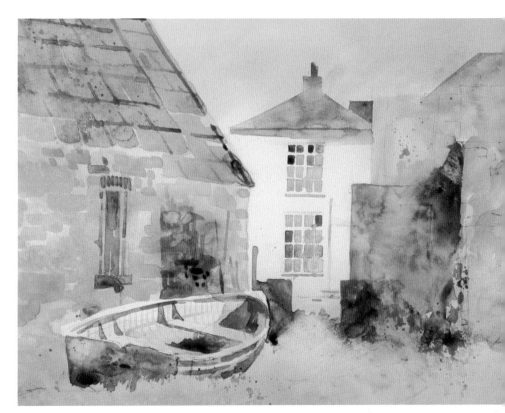

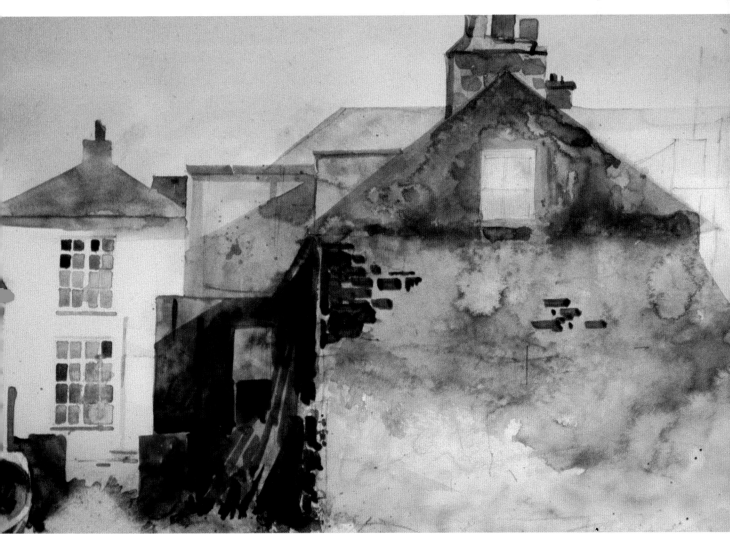

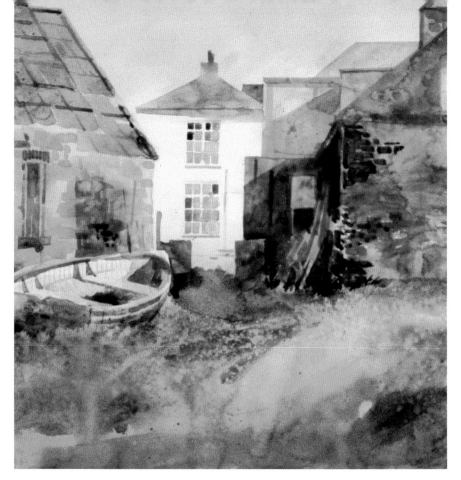

9. Below the pitched roof I fragmented the area by brushing, flinging, and spattering textures and forms that would eventually be developed into a stone wall. Contrast on the ground was increased to show areas of sunlight and shadows.

10. The dark panes of glass were added to the window just below the peak of the roof. I returned to the wall and worked on describing it by painting darker values in between the stones. The dark shape leaving the right side of the picture cast a shadow across the wall and part of the slanted roof. I washed that in with careful attention to where it met the sun-struck grasses at its base.

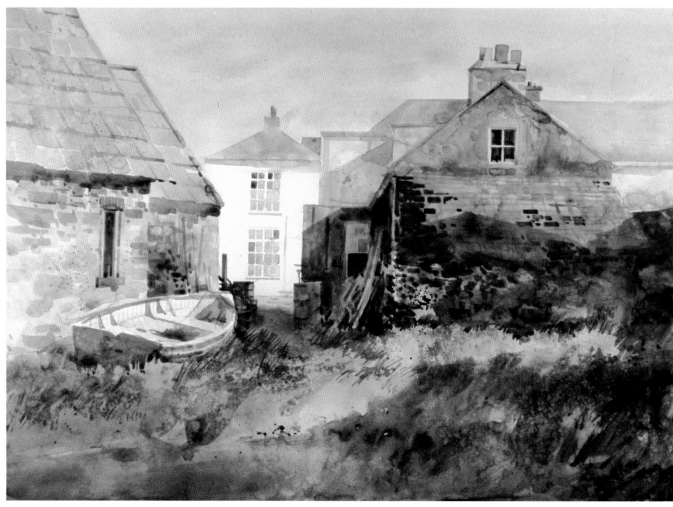

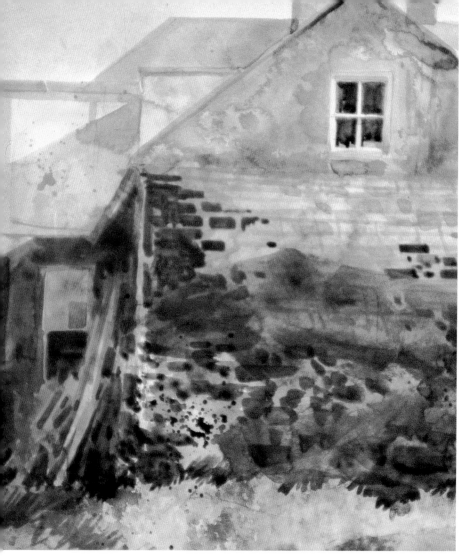

11. Some areas needed to be completed and slight adjustments seemed necessary to pull the painting together. The sky was darkened and another tint was placed over the light building. Transparent modeling was used to indicate the structure on the extreme right, to darken the shadow areas near the bow of the boat, and to extend the values in the wall on the left. More washes were laid over the boat, the stern was darkened, and ropes and rigging were put in. Warmer washes were placed over the sunlit grass, and the cast shadows in the alley and across the foreground were darkened.

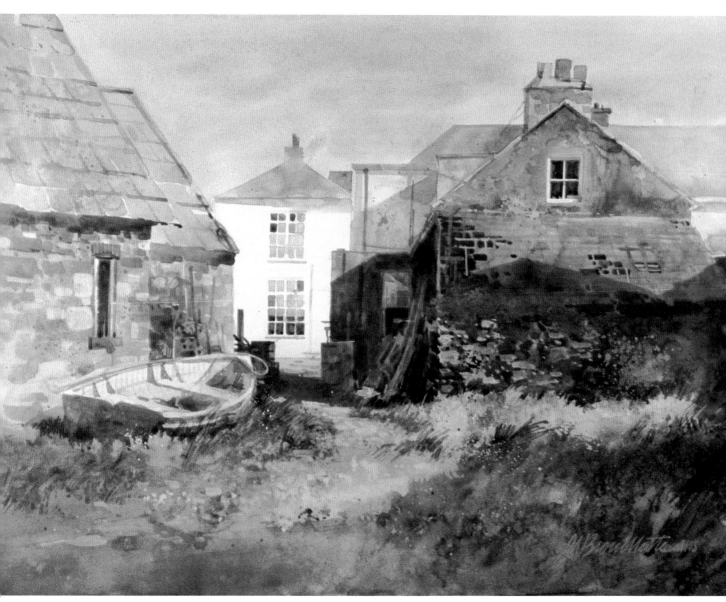

The Pathway, acrylic on illustration board, 14¼″ × 20″ (36.30 × 50.80 cm).

12. To complete the painting, I put in the finishing touches with opaque colors—colors with titanium white added. Starting from the left I painted light stones into the wall and a few lights into the window. Small details were added to the boat and the objects in the alley. The peaked building's roofline was touched up a bit along the window, and light lines were added into the dark openings in the shingled roof. Overgrown ivy and lighter stones were painted into the wall below the roof. Sunlit grasses were placed against shadows, and the pathway rocks and open dirt areas were emphasized with middle and light values. All of the opaque areas lit by the sun were glazed with warm colors, and the opaques in the shadows were glazed with cool colors.

With these last touches, I placed a mat around the painting, and after I looked at it for a while, an old saying came to mind. "If it ain't broke, don't fix it"—so I didn't.

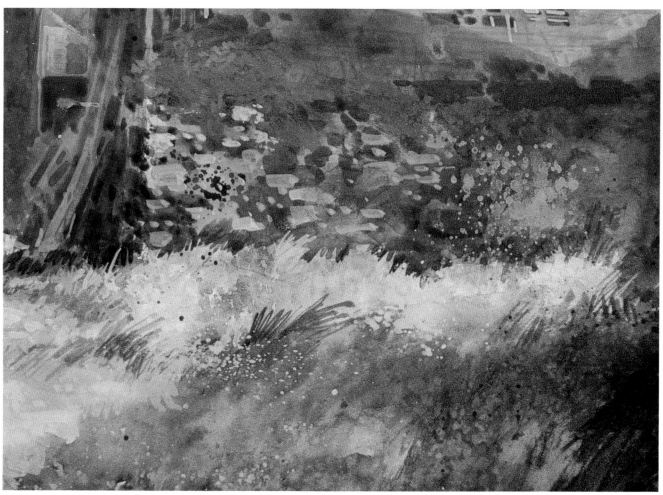

Infusing Excitement into your Painting

No matter how long you paint, the time will never arrive when every effort results in a satisfactory painting. In the middle of painting *Broken Leaves,* I became dissatisfied and considered starting over. I continued working on the painting in the hope I could resolve its problems and show how to change what seems like a failure into a rewarding, exciting end.

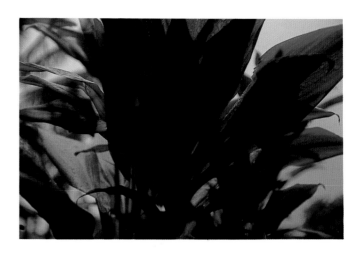

The plant that was used as the model for this painting was photographed twice—close-up and from a distance. The two slides were then sandwiched into one slide holder to produce the image you see here.

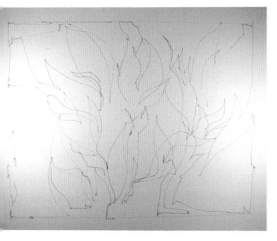

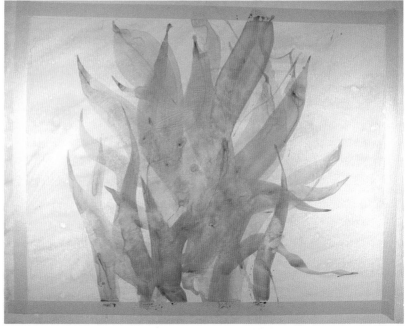

1. A contour drawing was my initial attempt at personalizing my subject. Its configuration was loosely redrawn on the painting surface.

2. The leaves were blocked in as overlapping transparent shapes. I let each layer dry completely before I added another.

3. I continued the layering until complex arrangement of shapes, colors, and values were developed.

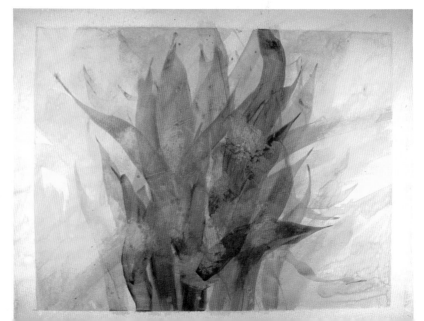

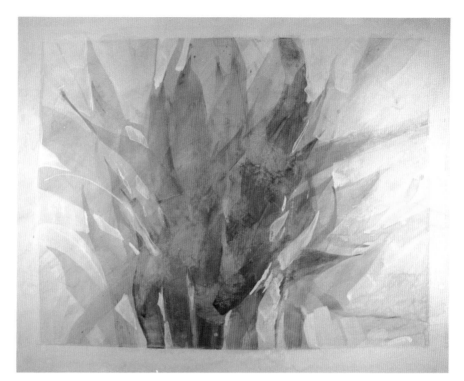

4. I refined the subject by painting against and into the positive areas with gesso diluted with water. A transparent wash of one color was brushed over the leaves to unify the dark pattern.

5. Sections of the leaves were darkened and more layers of thinned gesso were used to confirm some of their edges.

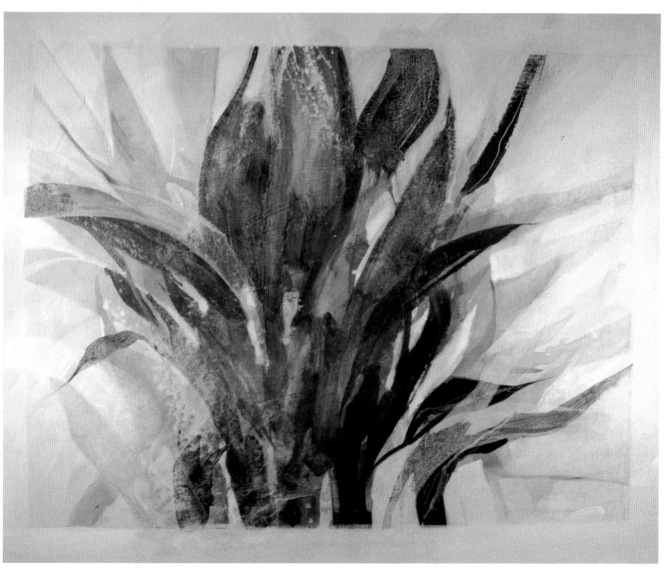

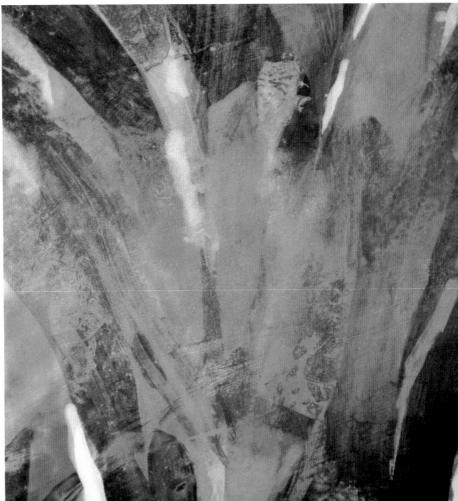

6. To increase the covering capability of my colors, I added titanium white to their mixtures and began to describe the leaves with light modeling. Various values and colors were painted into the subject to shape and model these elements. I used water in some instances and waxed paper in others to break up and add texture to these opaque passages. Notice the way opaque white was washed over some of the outer leaves to push them back.

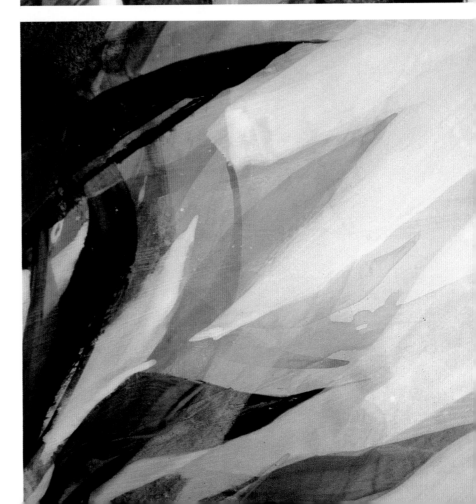

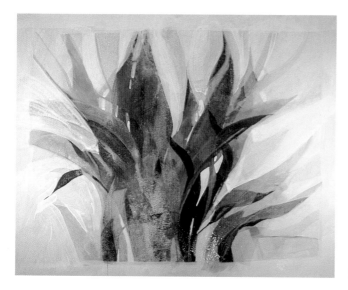 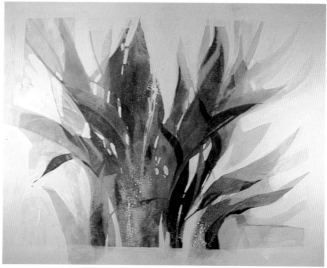

7. The values between the positive and negative areas were lightened by painting the background with opaque colors of a lighter value.

8. Having increased the contrast, I decided to adjust the values slightly by softening some of the darks in a few of the leaves with a spattering of opaque color.

9. The hard-edge border I had developed inside the painting began to seem too conspicious and confining, so I obscured its outline by painting leaf shapes across its boundary and painting over it with opaque colors until it was completely lost. At this point I realized that the painting lacked a certain sense of excitement. The leaves had taken on a fan-like redundancy that lacked visual interest.

10. To work out the problems, I changed some of the leaves that were too similar and obscured some of their edges with thinned layers of semi-opaque paint. Even with this change, however, the work continued to deteriorate and I actually thought about calling it quits. But I was eventually able to produce the elusive quality that had been missing—excitement.

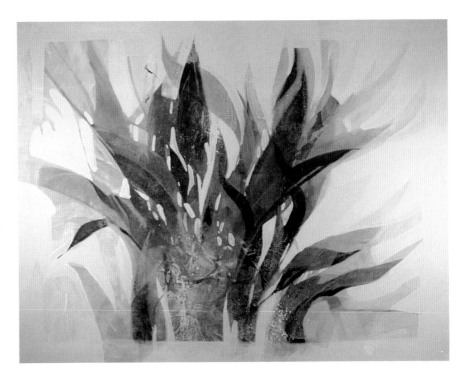

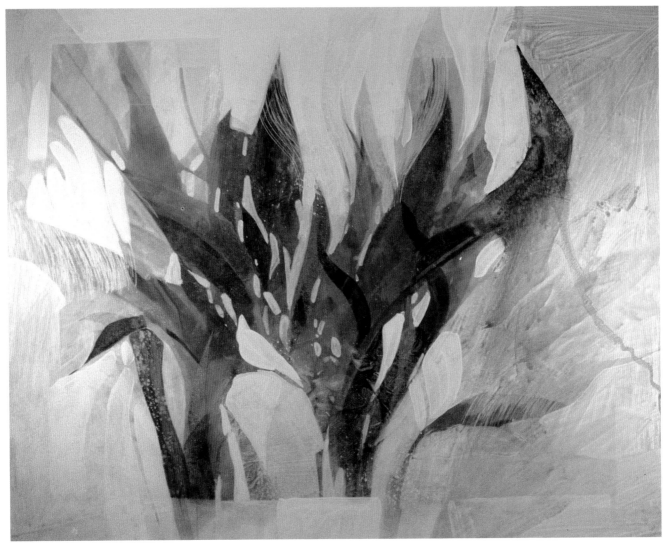

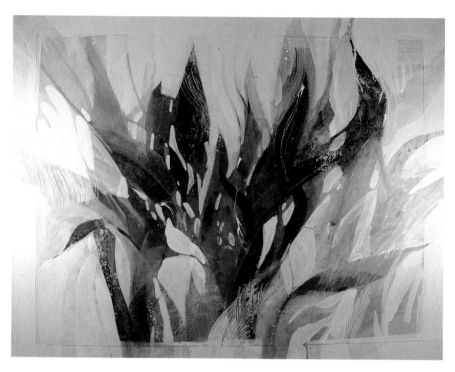

11. Encouraged to go on, I painted over some of the spotty areas and went on to reorganize the background. I used a sharpened stick that had been dipped in paint to introduce some delicate line work.

12. Lighter colors were added to the leaves and the negative spaces. The change from despair to hope took more time than the telling, but now I could see I was nearing the end of my zigzag journey.

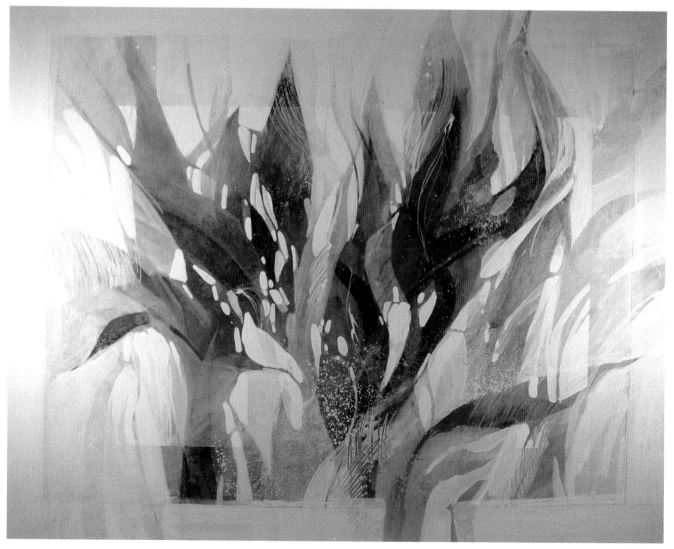

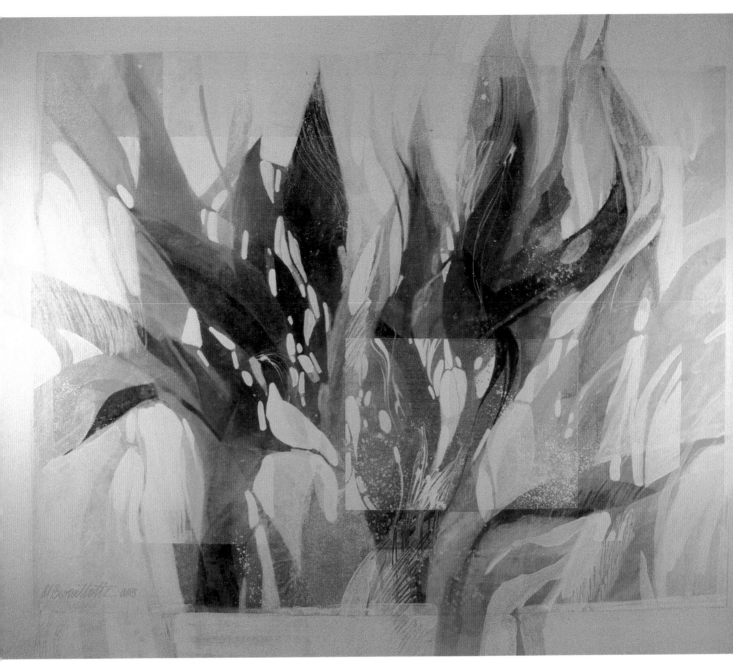

Broken Leaves, acrylic on illustration board, 24" × 30" (60.95 × 76.20 cm).

13. The leaves were broken up further by painting geometric patterns over them. To complete the painting, I added a shape to the lower right of the composition and intensified some of the colors in that area. In this case, the process from the beginning to the finished work did not flow smoothly. The painting took many unexpected turns as it slowly revealed its true identity. In retrospect, I'm glad I was able to get back on the track so that you were able to witness what happened along the way.

Making Changes in a Painting

I rarely find a subject I want to paint that doesn't require a multitude of revisions. Some of the alternations are so subtle they are almost impossible to see. Other changes are so extreme they would be obvious to anyone who had seen the actual location. That is why I have included the original photograph.

In this painting, I made two essential changes from the photograph that I thought were necessary to improve the design of the painting. The water area was so small it seemed unimportant. I increased its size so it would be a stronger element in the overall composition.

The cliff in the immediate foreground ran directly into the lower right-hand corner of the composition. A shape leaving a painting at its corner can get a lot of unwanted attention, so I decided to take the cliff out of the bottom right edge where it would be less likely to attract the viewer's eye.

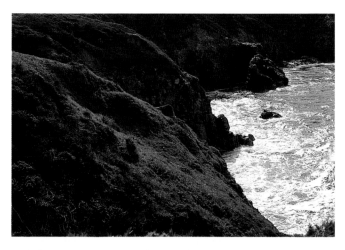

1. I began by covering the illustration board with one coat of gesso. When it was completely dry, I roughed in the dark cliffs with mixtures of burnt sienna and black. While the paint was still wet, I lifted and wiped out some shapes with a paper towel. Then I added more texture, by waiting until the paint was almost dry, then spraying with clean water and wiping the moisture off the surface. The ink drawings show the very simplified contours of the basic shapes at this initial stage. As you can see neither contour is particularly interesting to look at.

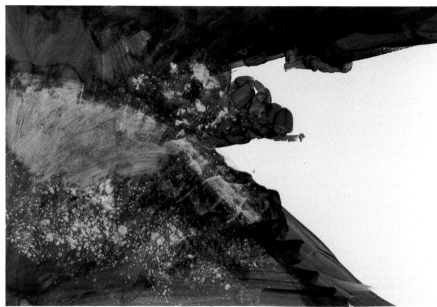

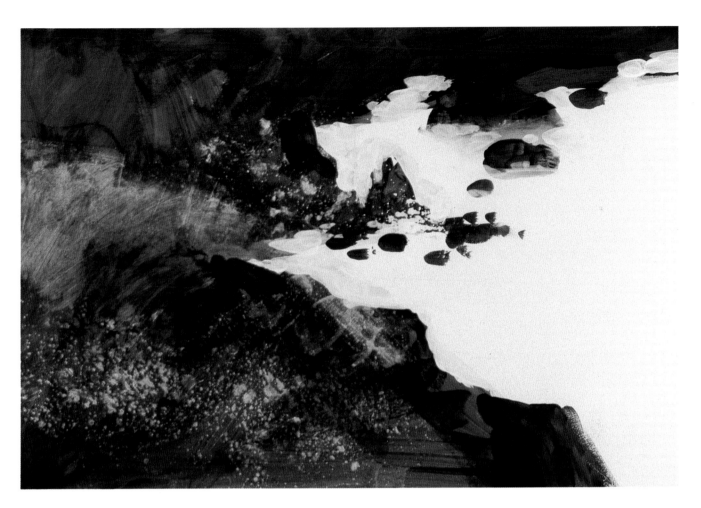

2. To make the interplay of dark and light shapes, I painted into both areas, using gesso to extend the light area into the dark. Then I reversed the procedure and enlarged the dark into the light with transparent values. The outline tracings I made—*after* I had altered each area—clearly show the improvements that resulted. When I was sure that I had refined the darks and lights into an acceptable arrangement, I began to describe the cliffs and water.

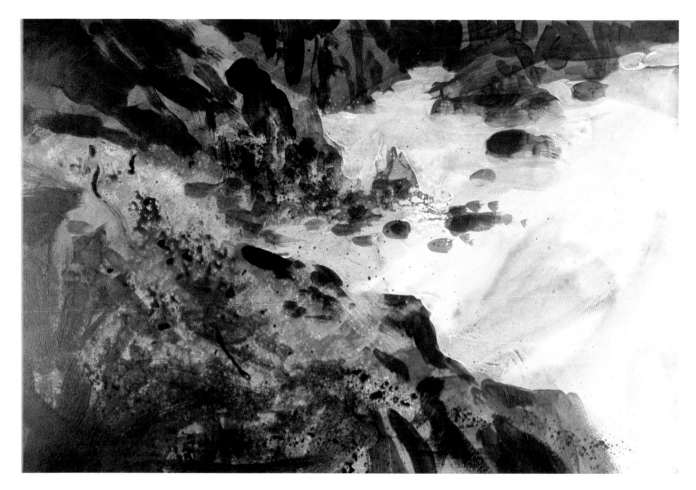

3. I began by adding *small* amounts of titanium white to each color as I mixed it on the palette. I painted these values into the cliffs and water. The addition of larger and larger amounts of titanium white to color continued until I was painting with my lightest values.

4. When the modeling was complete, I added more color to the painting by brushing on transparent glazes—no white—of warm and cool color. The warm areas of the painting were glazed with Turner's yellow (Liquitex), yellow oxide, cadmium orange, cadmium red light, and Acra violet. The cool, dark shadow areas were glazed with cerulean, ultramarine and phthalo blues.

5. The effect of an overall glaze on any shape can flatten it. Once the surface was dry I painted into each area with my middle and light opaque values to reestablish the modeling.

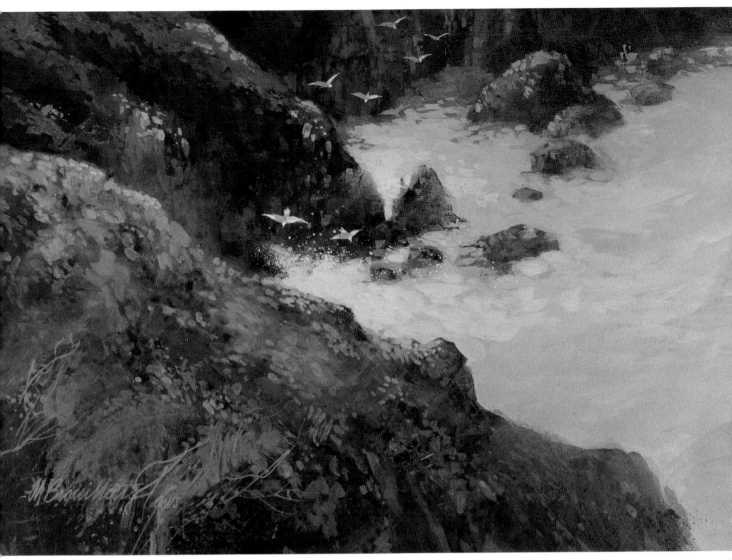

Cliffs at Big Sur, acrylic on illustration board, 15" × 18" (38.10 ×, 45.72 cm).

6. I added the seagulls because I wanted to emphasize the visual sensation of looking *down* at the cliffs and the ocean. That is why I placed the seagulls *below* the horizon in a vertical arrangement. I also wanted to suggest scale. By comparison the birds suggest the size of the cliffs. They seem a natural element in the environment that the painting suggests.

A closer look

The arrangement of your dark and light block-in provides evidence of your *original* design. Working on top of that, your personal choices of size, value, color, and shape add to the originality of your concept. Next time you tackle a subject, try doing a series of paintings where the distribution of the light and dark arrangement is worked out *before* you begin to consider the particulars of describing your subject.

Working with an Experimental Surface

In this final demonstration, I will show you a more experimental approach using collage. I begin by preparing the painting surface, layering it with rice and tissue paper. The rice paper is heavyweight with a linear surface texture that is variable. The tissues are transparent and semitransparent, and their surface is smooth. The layering is strictly experimental, but the colors I use to tint the papers will be directly related to the colors in the completed painting. The overlapping of colored opaque and transparent papers produces effects that are relatively unplanned. Later I may enlarge, alter, or paint over them. In any case, the unpredictable quality of layering brings a nonrealistic dimension to a landscape that would be difficult to achieve in a planned painting.

1. The papers were torn into random sizes; they were not cut or torn into shapes that would suggest the objective content of the painting.

2. I colored the papers with diluted acrylics and dried them. A half-and-half mixture of acrylic gloss medium and water was used to glue the papers to the illustration board. A heavy application of the mixture was brushed into the area that would receive the papers. I positioned the paper and covered it with the mixture. I used a large flat brush to remove any trapped air so that air pockets would not result.

3. As you may be able to see, not all of the papers were colored before they were added to the assemblage. I avoided to the best of my ability any conscious effort at some sort of orderly sequence or placement.

4. I continued to layer papers until the surface of my board was covered. I kept myself from considering any realistic imagery. Below are some close-ups of the papers so you can see what I did.

5. I wanted to increase the textural content of the surface and break up some of the large, solid color areas, so I began to spatter light and dark values over them. Dry brushwork was also used to fragment and obscure some edges. Semiopaque washes (color mixed with white) were brushed into the sky and water areas to lighten and unify conflicting elements. When I completed this phase, I could see numerous possibilities for inclusion of some of the effects in the painting. The experimental beginning was over.

6. The subject was beginning to emerge, but one important element was missing. A tangle of branches was indicated in the immediate foreground. I painted a second layer of color into the sky and water and then laid a transparent glaze into the dark shape on the left to heighten its color.

7. The edge of the distant shoreline and the outline of the foreground trees were changed by painting the sky opaquely. The water was next: As I layered a second value over it, I made alterations in the bottom edge of the shoreline and reconstructed the lower part of the trees and the branches in the water. Additional branches were painted into the dark area in the foreground.

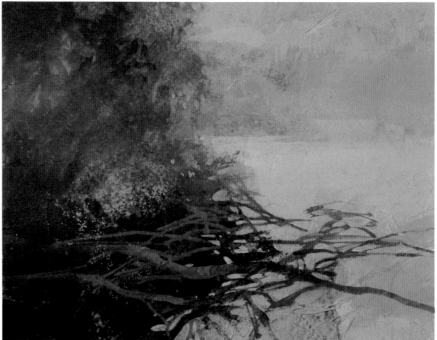

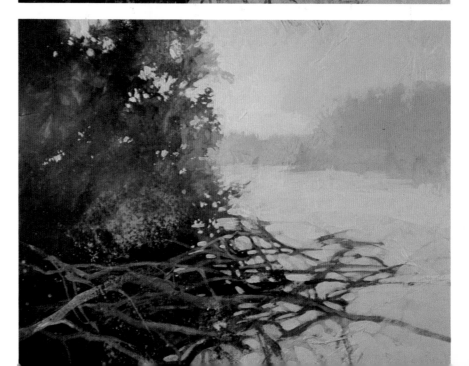

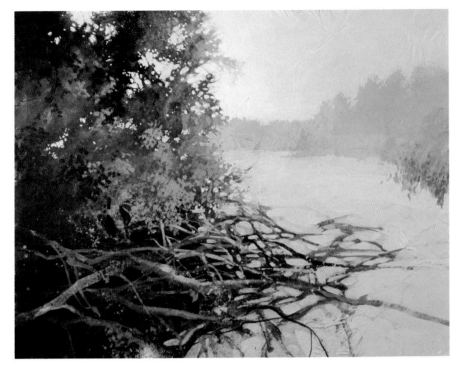

8. I applied another layer of opaque paint to the sky to flatten it. Dark transparent colors were worked into the foreground trees followed by opaque clusters of leaves and branches placed over the darks. Because I wanted to increase the sense of depth in the foreground branches, I darkened the areas behind some of them and lightened others with opaques. A dark shape was painted into the extreme right of the composition to counterbalance the large dark on the left. You can see how I worked in the details below.

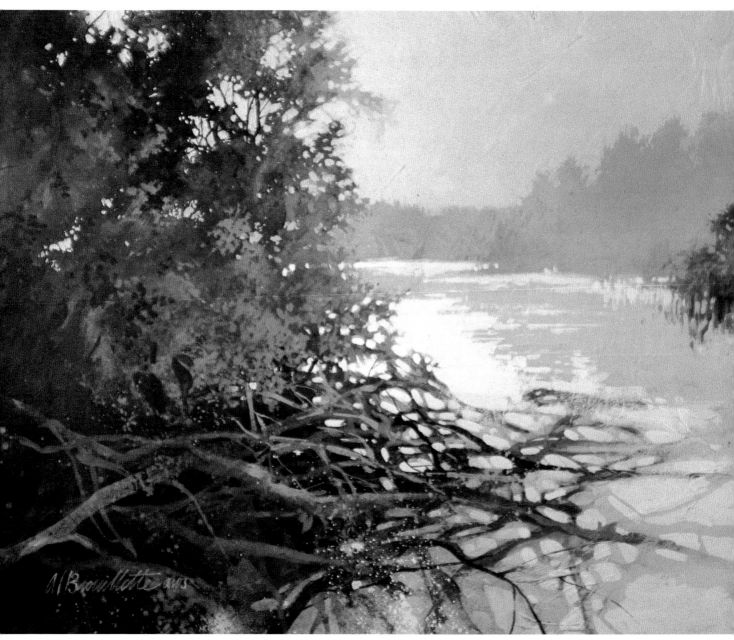

The End of the Beginning, acrylic on rice and tissue papers, 14" × 18" (35.56 × 45.72cm).

9. I layered successively lighter values into the water and established my center of interest around the outline of the dark trees. Bright touches of color were centered in this area also. Soft blues were added against the darks to take advantage of color temperature contrast, and more modeling and description were painted into the dark shape located in the right side of the composition.

A closer look

The experimental approach I used at the beginning of the painting contributed to the final effect, but the most important reason I chose for starting this way was the freedom it allowed me to explore and discover new ways to express my subject. Because my mind was not made up about what I wanted the painting to be, the possibilities for personal expression were increased.

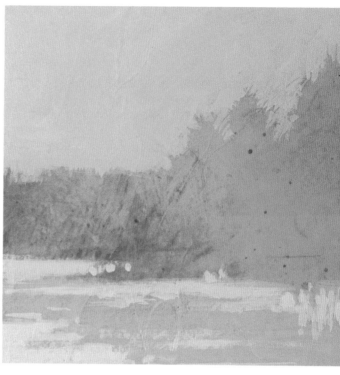

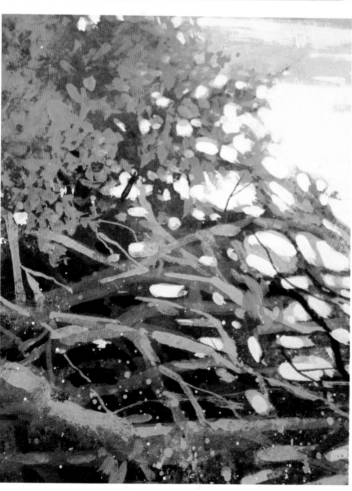

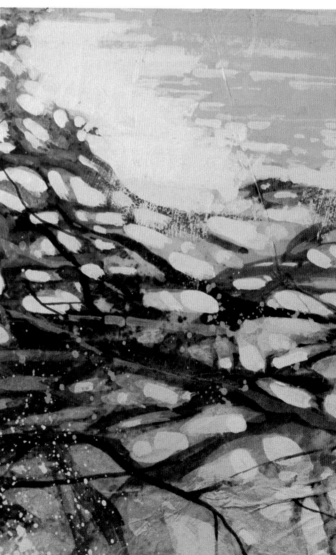

Evolving Ideas Through a Series

When I first began to paint, I considered myself a realist, which, of course, is not a particularly unusual direction for a young artist to take. When you're struggling to learn your craft, you often give little attention to personal expression. Most of my effort was focused on trying to control my medium. Other considerations, such as color, value, rhythm, or design, were probably not part of my painting vocabulary at that time. But in a way, by concentrating on my craft, I was able to learn it quickly. Once I felt comfortable with the mechanics of painting, factors other than description became important. However, I had not reached that plateau when I did the first bird's nest.

Bird's Nest, acrylic on illustration board, 15" × 20" (38.10 × 50.80 cm).

I can remember looking at the nest using a magnifying glass, very much like a scientist looking for facts in order to come to some conclusion. At that time it was comforting for me to think that once I had found every visible fact there was to know about my subject, I could paint it. The result of my limited and confining expectations is evident. The first bird's nest could have been painted by thousands of nameless craftsmen who mistakenly believe craft alone is art and an end in itself.

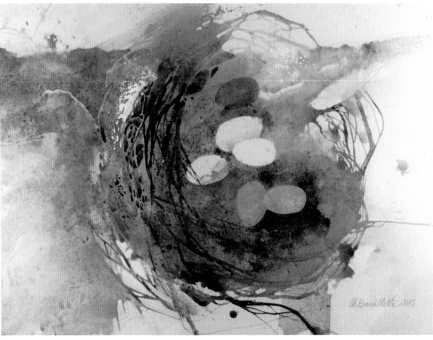

Bird's Nest, no. 1, acrylic on paper, 21½" × 28¼" (54.61 × 71.76 cm).

Once I had learned the painting skills I needed, however, craft ceased to be the factor that determined what I wanted to achieve in my paintings. Slowly but surely my technique loosened up, and with each success my confidence grew. I began to react to the possibilities of my painting as I was executing it, and this approach required me to rely on my intuition. The result was the creation of images that were—and still are—surprising to me. I don't want to give you the impression that the total creative process comes off the top of my head. The preliminary observation of my subject, the drawing, and the value composition are important compo-nents that prepare me informationally and esthetically. They help provide the freedom to experiment and explore that which I otherwise might not be able to handle.

I had been painting in the realistic style described for about four years when I found another bird's nest. My immediate thought was that I had done that before, but I was interested in seeing positive evidence of how my work had changed by doing the same subject. One major variation from my former approach was to paint without any drawing guidelines on my watercolor paper. I wanted to force myself to rely on my reaction to color, value, and shape as I painted, and still achieve my first objective—a bird's nest.

After I completed the first painting, I was pleased to see that I was able to create a totally new image from the same subject.

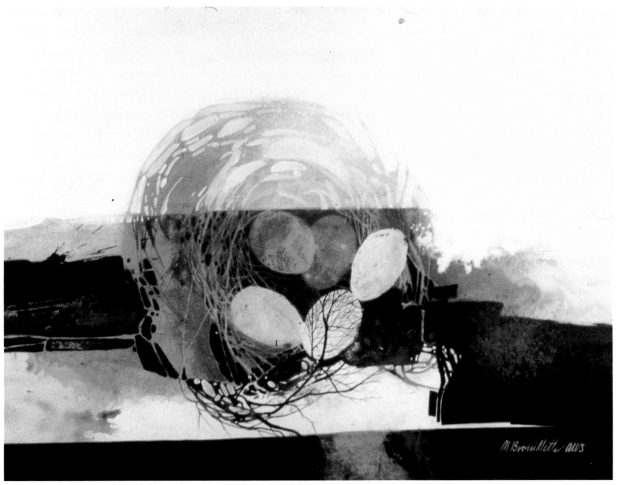

Bird's Nest, no. 2, acrylic on paper, 20¾" × 27⅝" (52.71 × 70.17 cm).

I realized I could paint the same bird's nest many times without arriving at the same artistic conclusion, so I put my theory to the test and did two more paintings.

When students ask me what or how they should paint, I advise them to paint what they like, paint what they feel, and paint what they are. No two individuals see the physical world in exactly the same way. No two people respond to its visual imagery identically. This realization may prompt you to learn your craft as quickly as possible so that you can move on to the much more satisfying and creative world of personal and intuitive painting. You don't have to try to be different. You are!

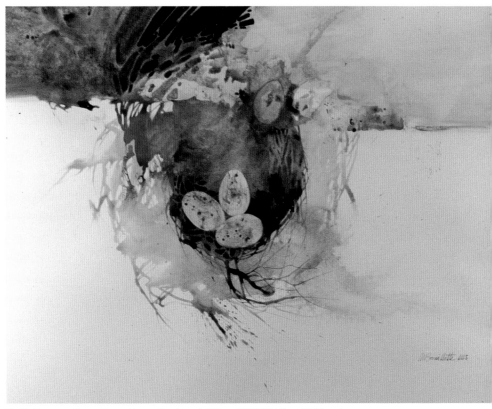

Bird's Nest, no. 3, acrylic on illustration board, 20" × 27⅜" (50.80 × 69.53 cm).

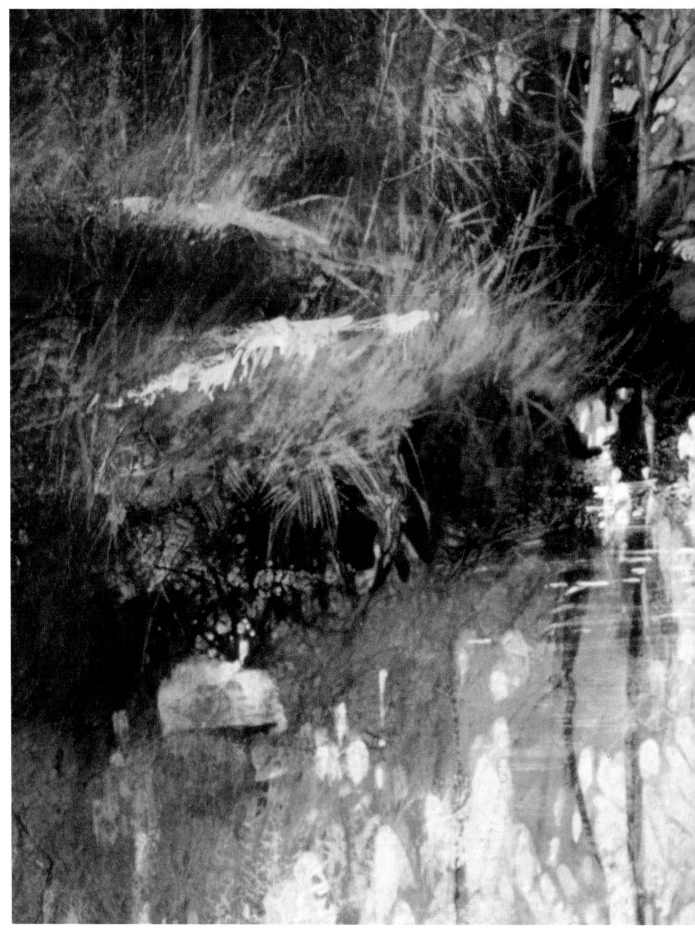

Light on the Water, acrylic collage on illustration board, 13" × 15" (33.02 × 38.10 cm).

Reviewing the Basic Ideas

Painting intuitively

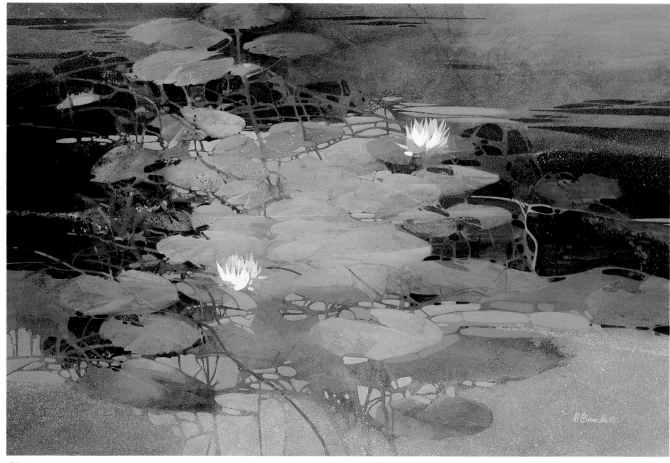

Dimensions Three, acrylic on Masonite, 32" × 48" (81.28 × 121.92 cm).

My attitude toward this painting is largely the result of the emotional response I had while I was doing the work. If it was fun to paint, I liked it. If I had a difficult time painting, I may have had negative feelings about the work. This is not to say that having fun or experiencing difficulty determines the quality of the painting. Some of the tough ones I consider a victory of mind over emotions.

In 1978 I painted a 10¾" × 16" (27.31 × 40.64 cm.) panel that I called *Floating Garden.* I remember how everything seemed to fall into place. I thought about that pleasant experience for a month before I made the decision to relive that wonderful moment by painting the same subject in a much larger format.

This was to be the largest work I had ever tried, so I planned to devote one or two hours a day developing it. The first week extended into a month and that month extended into two months with no end in sight. I was having difficulty sustaining my initial enthusiasm. I was also faced with a couple of large painting problems that seemed beyond my ability to resolve. After eleven weeks, the work ground to a halt, so I put it aside on an easel and got into some other paintings. I would stare at that unfinished painting a dozen times a day in the hope that the answers to the problems would magically appear on its surface. I also thought about ridding myself of the physical evidence of my ineptitude by destroying it.

My wife, Kathleen, was also well aware of my frustration, so she suggested a radical solution: "You have a lot of effort and time invested in that painting. Why don't you take the largest brush you have, load it with paint, and make some changes. What do you have to lose?"

It was good advice. If you can't solve the problem, *change the problem.* That is what I did, and I was able to complete the painting (with a sigh of relief) in three days.

I did learn that no two painting experiences are exactly alike. When you do have fun painting, just count your blessings. When you can't resolve a problem, keep making changes until the answers start to come.

Painting light and mist

Burning Off, acrylic on illustration board, 14¼″ × 18″ (36.20 × 45.72 cm).

When I saw the sun rising over this fog-bound marsh, I knew I had to paint this scene and its quiet beauty. I wanted to record the softness of form and simplicity of detail that were a large part of its appeal.

I began by applying a transparent wash of neutral gray over my painting surface. When the wash was dry, I sketched in the major shapes: the sky and sun, the marsh grasses, and the water. Over the sketch, washes of color were layered, and with each wash, I lifted shapes out of the wet pigment and added texture by using crumpled paper towels and water spray. This process continued until a rich dark surface resulted.

Using the still-visible drawing as my guide, I began to indicate my light areas by adding small amounts of titanium white to each color as I mixed them on my palette. I roughed in the sky and water first. A conscious effort was made to avoid painting

solid, hard-edge shapes, so the outer portions were softened with dry brushstrokes and blurred with a paper towel dipped in semiopaque paint.

Once the sky and water were loosely defined, I made alterations in the tree and grass silhouette with transparent darks. The changes were made wherever I thought a visual improvement would result. The choices made were not overly intellectualized, but were the result of personal taste and intuition.

When I achieved the effect I wanted, I placed a mat around the painting and looked at it from a distance. The arrangement of the light and dark areas was pleasing and exciting to me, so I felt confident I could continue to describe the subject.

The light areas were a little dull, so I glazed color over them. The darks were too dark and were lightened by washing diluted titanium white over them, then dried and glazed with

transparent color. Gradual transitions in the modeling of the sky, sun, and water areas followed by painting in successive layers of increasingly lighter values. The lighter the value, the greater the amount of titanium white I mixed into the color. The modeling and description in the grass and trees were handled the same way, but smaller amounts of white were mixed with the colors so that the value changes would be less distinct. The layering took time because I wanted the transition from my darkest lights to my lightest lights to be gradual, in order that continuous unity of value and a softening of modeling would result. Repeated alterations and refinements were also possible.

I completed the painting by layering in transparent glazes wherever I wanted stronger color, and also as a means of pulling together small fragments of differing values.

Positive and negative

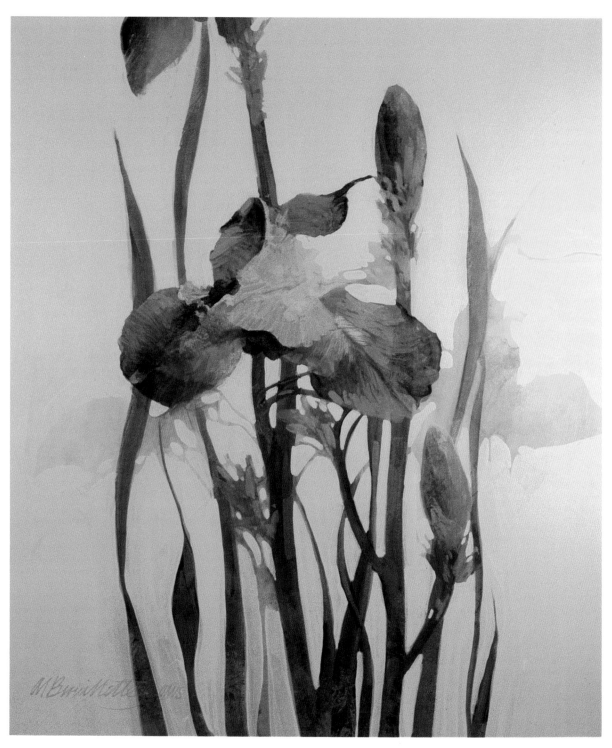

The Arrangement,
acrylic on illustration board,
19¾" × 17" (50.17 × 43.18 cm).

Because I wanted a close-up view of this subject, I cropped the top and bottom of the photograph so that the middle area would be emphasized. The flowers were placed in the upper half of the painting, slightly to the left of center to create a slightly off-balance composition.

The aesthetic and design choices I made during the process of working on this painting are essential to its success, but they should not be so obvious that they distract the viewer from the simple act of enjoying the painting. My intention here was to alter, change, and revise, while maintaining the integrity of the material.

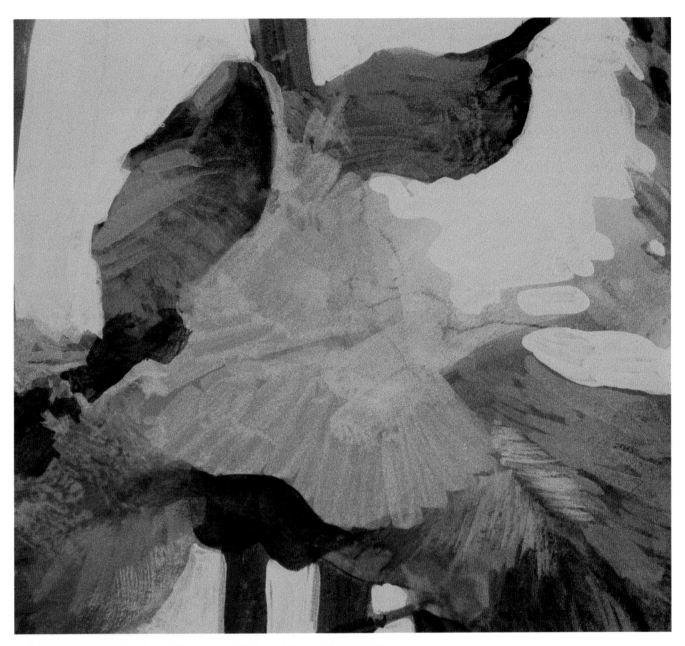

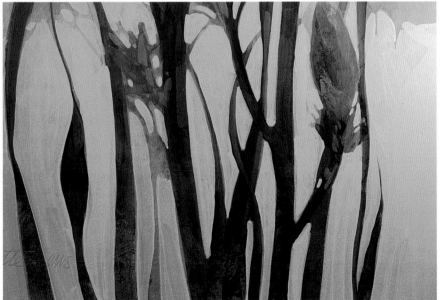

Details. Color was an important consideration in the design, so I painted the blue, lavender, and violet flowers against a contrasting warm background of red, orange, and yellow. A secondary contrast is the complex modeling of the flowers by comparison to the flat treatment of the background.

I went to great lengths to insure that the placement of the stems and leaves (positive) would result is a background (negative) of numerous shapes and sizes.

Reality and interpretation

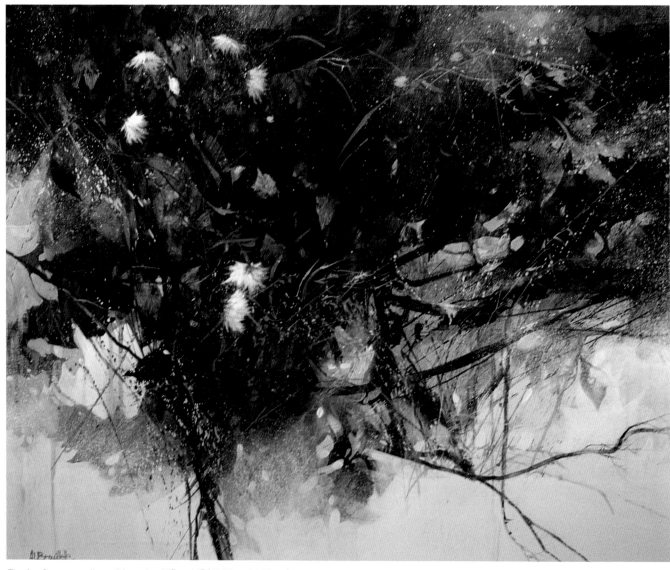

The Ice Storm, acrylic on Masonite, 25" × 30" (63.50 × 76.20 cm).

You can't be sure when or from where the inspiration for your next painting will come. Painting ideas can occur when your mind is miles away from your surroundings as well as when your attention is focused on something that is going on around you. The 1973 ice storm that happened in my area of Texas is a good example of the latter.

For those of us who live in the North Texas area, experiencing a "blue norther," or a sleet storm, is not all that unusual, but when it happens it does get your attention. When the storm had passed, I went outside to see what damage had occurred to our trees and bushes. Everything was glazed with a coating of transparent, reflecting ice. In the flower bed lay a tangle of last summer's debris and a handful of fall chrysanthemums captured in winter's crystalline grasp. Sleet covered most of the area except for taller vegetation.

Although *The Ice Storm* is the obvious manifestation of that experience, the long-lasting effect has been a conscious effort to interpret what I see as *simple value statements* into which I will eventually describe the realistic imagery I love.

When you begin to visualize your subject as shapes that will decorate a two-dimensional space, your paintings will take on an added visual strength that will elevate them above the predictable results of a literal interpretation of a subject.

Avoid clichés—
choose an unusual viewpoint

How many times have you looked at paintings that were totally predictable with no surprises? It's almost like looking at yourself in the mirror in the morning. Some television shows and movies are the same way. You know what the next line will be before it's spoken. We know what comes next because we've seen it before.

Mud Low could have also been a cliché if it had not been for the viewpoint I selected. Before I began to paint I gave the design of the picture a great deal of thought. The first view I had of these boats was from the dock on the right, where I saw the boats strung out in a simple horizontal line—not very original! Then I walked around and looked at the boats from every possible angle. I finally settled on the arrangement you see here—a vertical line of foreshortened boats. Their vertical direction was balanced by the horizontal shapes of the dock, anchorage lines, and water movements.

There is no sense in repeating what has already been done. Thousands of painters are already involved in that. Give the viewer—and yourself—a fresh and original viewpoint.

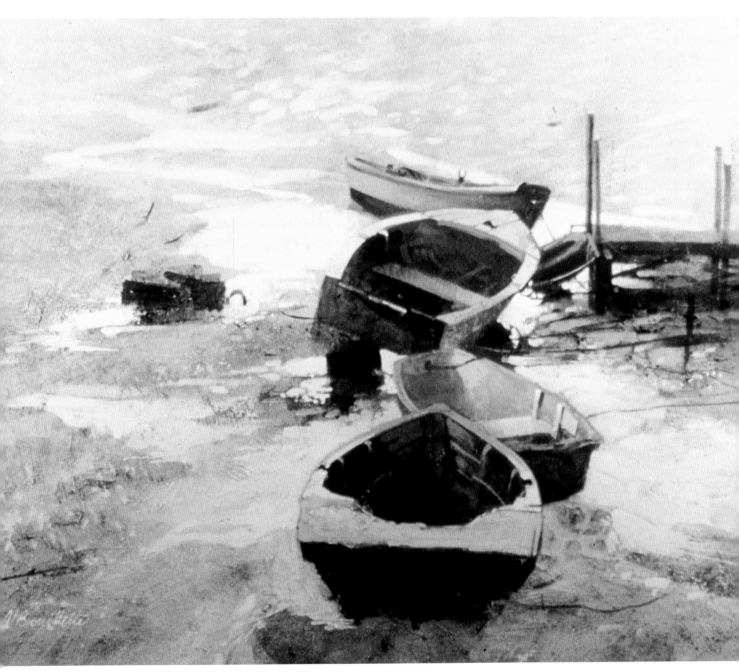

Mud Low, acrylic on canvas, 18″ × 24″ (45.72 × 60.96 cm).

A barn is not a barn . . .

The location of this winter scene could be anyplace where barns stand and snow falls. Barns have been represented in thousands of paintings and picture postcards. You might ask why I would choose to use this subject in one of my paintings. My answer is that my primary intention was to create an interesting design. That a barn was used is incidental.

To begin with, one of the buildings is located in New England, the other in Texas, and both were photo-graphed in the summertime. The different parts were then assembled into a whole, something like a working a puzzle until everything fits.

The fact that one building was dark and the other light was seized upon as a way to establish dominance through contrast, which is why I positioned the barns as overlapping shapes. The eye is attracted by the contrast, as it would be to a dark tree in a snowscape or a lighted candle in a dark room. Secondary contrasts included in the design are the geo-metric versus the organic found in the dark shape on the left, the large and small comparisons of the fence line and post, and the simple-complex, light-dark relationships of the two sides of the painting.

To me, the subject is not sufficient in itself. Recreating the subject in personal terms, though the use of selective design ideas, gives the barn attributes it did not possess before it was transformed into a painting.

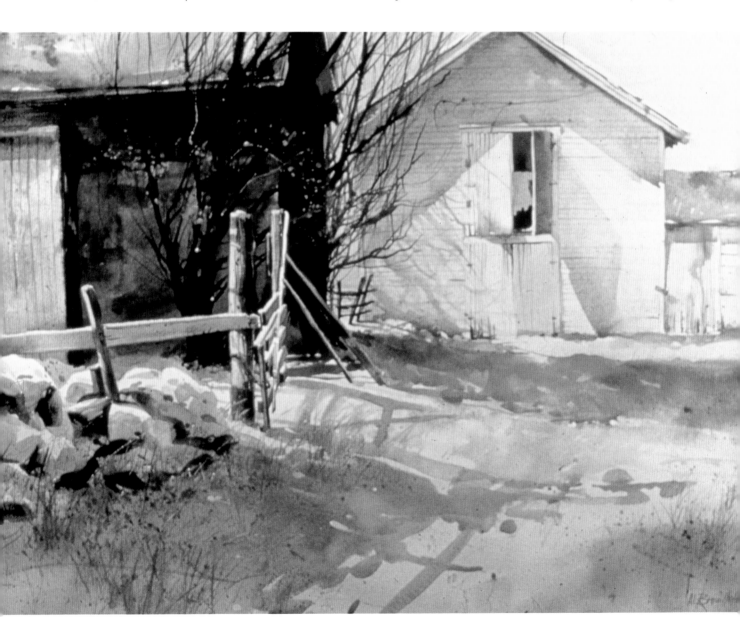

The End of the Lane, acrylic on paper, 21" × 29" (53.34 × 73.66 cm).

The honest response

Rebuilding, acrylic on paper 17" × 19½" (43.18 × 49.53 cm).

When I conduct a workshop demonstration, I'm working against the clock. The limited time element can work to my advantage. I enjoy a challenge! I also have modified my thinking so that I can accept the possibility of failing. My outlook has given me a freedom I wouldn't have otherwise.

Rebuilding is a classroom demonstration. I painted it transparently because I thought a slapdash approach would show the students it's possible to work loosely and still maintain control over your medium.

As the clock ticked, the excitement and tension I was experiencing goaded me into making quick decisions that ordinarily would have taken me more time to think about. When the painting was completed, I could see that the excitement of this rollercoaster ride had somehow been transmitted to the painting.

Your intuition can add a dimension to your work that reason alone cannot supply. The next time you paint, put yourself into a quick response situation by setting a time limit for its completion. It's possible that the results could be more revealing than anything you've put down before. If a painting is to be honest, it must come largely from the subconscious.

The center of interest

Early American, acrylic on paper, 21" × 29" (53.34 × 73.66 cm).

This Texas Star quilt was a gift from a relative. I enjoyed the colors, craftsmanship, and beautifully executed design. Then I thought about using it in a painting. I had seen quilt motifs in paintings before, but in some cases their designs dominated the picture surface or they were displayed in a way that seemed staged or improbable. I wanted a situation that would show the quilt as one element in believable circumstances. I finally chose to do a sleeping figure covered by the quilt.

To make sure the model's head would be the center of interest, I painted her hair as a dark swirling mass positioned against a white pillow. Two of the Texas Star points were used to direct the eye toward the model's head. Then I lessened the visual strength of the quilt's design by rendering it less precisely, diminishing its contrast, and by placing much of it out of the picture.

Making choices requires thought and energy, but selection is necessary if your picture surface is to be organized. If you don't decide, then the decision is made for you. In that case, all of the elements in your painting will be equally important—which, in effect, means none are important.

Letting it happen

Morning Mist, acrylic on canvas, 16″ × 20″ (40.64 × 50.80 cm).

My experience with this painting was not a once-in-an-artistic lifetime occurrence. It had happened before, and I hope it will happen again.

Leaning against a wall in my studio was a painting done during a classroom demonstration that did little for me, other than serve as a reminder of my incompetence. So, in order to come to terms in some fashion with the painting, I put the canvas on my drawing board, and with a total indifference as to what might result, I began to paint. After a few minutes, unusual colors began to appear, colors I'd never seen before. I never could have planned those combinations as I've never considered myself a colorist. But by relaxing and playing with the paint, I intuitively came up with results that were very pleasing.

What we have learned as artists is small by comparison to what we have learned from our total experience. If we can approach our work with less fear and trembling and develop a carefree state of mind, the possibilities of expressing, in a personal way, increase.

Facts and fancy

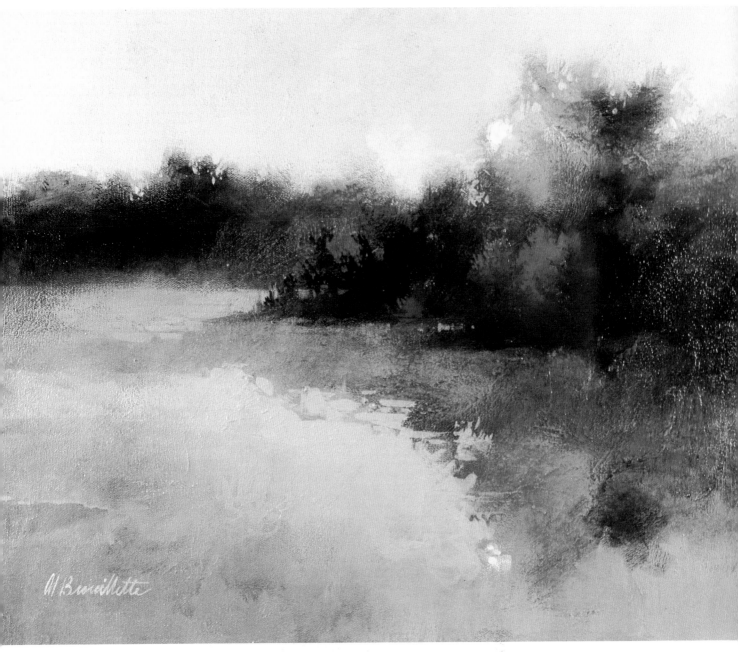

Sunrise at Chicopee, acrylic on canvas 16" × 20" (40.64 × 50.80 cm).

The reality of nature is always a consideration in my paintings, but reality is never my primary objective. My primary objective is to paint an image that resides in my mind, even though my imagining is directly related to the subject.

In *Sunrise at Chicopee* I was trying to indicate that a strong light source

affects those shapes that are close to it. For example in the painting, the closer the trees are to the sun, the more the trees lose their own coloration and assume the color of the sun. The light also obliterates the outline of the object.

Information I didn't think was necessary was discarded in the name

of artistic choice here. This is why I chose to alter the reflection of the trees in the water. In fact, the reflection is unlike the trees in value, contour, and color. My primary intention was simply to develop an exciting shape. My secondary goal was to include enough visual facts to suggest reality.

Choosing design ideas

Watching the Tide Go Out, acrylic on illustration board, 15″ × 18″ (38.10 × 45.72 cm).

When I composed this painting, my goals for this subject were realized by the use of the following design concepts: off-balance and counter-balance, contrast and similarity, movement and countermovement, and simplicity and complexity. Below is a list of how I used these ideas to bring about the results I wanted;

1. The figures and large rock were positioned to the right. Their weight was counterbalanced by the oblique movements and complex arrangement on the left.

2. The focal point was established by placing the heads of the figures above the horizon line and against a flat background.

3. The beach, water, and rocks were organized into a series of horizontal bands that became narrower as they moved toward the ocean, creating a feeling of depth.

4. Edges that were closest to the foreground were softened while a strong edge quality was used in the middle ground to direct the eye to the interior of the landscape.

5. An obvious horizontal dominance in the painting was neutralized by the vertical thrust of the figures and the shallow water on the sand.

6. Large, medium, and small shapes were incorporated to stimulate size comparisons.

Because the uses of design are not standardized but are open to interpretation, we can take advantage of opportunities to freely make our own choices. The choices we make are peculiar to each one of us and personalize our work.

The fleeting moment

Passing Storm, acrylic on rice and tissue paper, 15" × 15" (38.10 × 38.10 cm).

It had rained all night in Taos. Before dawn, I left by car for Albuquerque to catch an early flight to Dallas. By that time the storm had passed, and low clouds were clearing out just as the sun came up from behind the mountains. The channeling of the light between these two masses resulted in an intensified brilliance that ignited everything in its path. The effect could not have lasted more than a minute.

Most artists would have had a difficult time capturing this scene on paper with pen or brush, because by the time the necessary materials were assembled, this natural event would be long gone. A sketch from memory may have sufficed for a few artists, but for most of us there would be little to draw on other than a fleeting image.

As an artist, I've experienced the frustration of these "now you see it,

now you don't" happenings. So I am happy that I live at a time when I can be prepared for these events. As the car sped along, I lifted my camera from the seat beside me, aimed it over my left shoulder, and shot the entire spectacle on film. The resulting slides, though not perfect, gave me enough information to refresh my memory. The interpretive and intuitive part of the painting was up to me.

The illusion of space

The Road to Somewhere, acrylic on illustration board, 15″ × 25″ (38.10 × 63.50 cm).

I've never found a landscape that was perfect as a painting. I've not seen anything that was "ready made" as art, and the barren landscape that inspired this painting offered few clues to reveal its character. The land's surface did contain patterns, shapes, and movements that could be used to enhance the sense of distance. The absence of more visual evidence made it necessary for me to add elements that could support the idea of deep space.

For this painting, I chose a wide format and a high horizon to suggest a panoramic view of the countryside. The patterns of heather, grass, and cloud shadows in the far distance were painted in as elongated horizontal movements. Those in the middle ground and foreground were deepened to appear to be moving not only horizontally but also extending themselves toward the viewer. The road takes the eye over the foreground ridge and moves its way over successive hills into the interior of the painting. The location of the buildings on the far side of the rise plus the sheep on this side of the hill suggests a measure of distance. Background areas are painted with few details, while close-up shapes contain line, texture, and contrast.

What you think is what you see

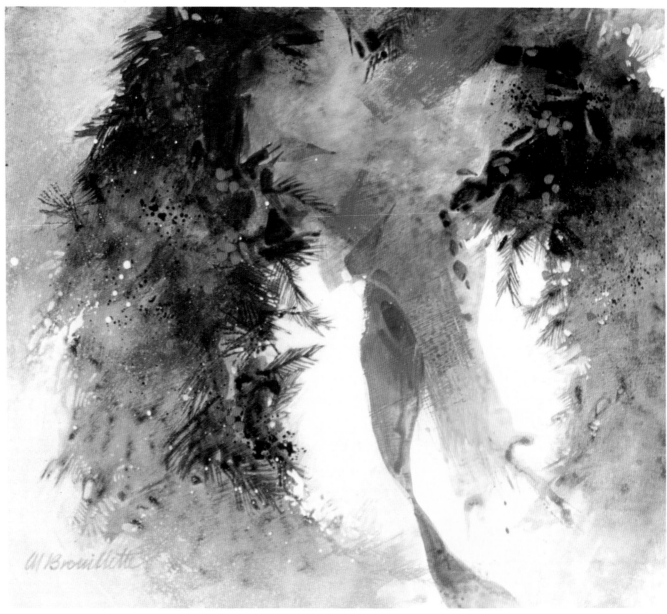

Christmas, acrylic on Masonite, 12" × 14" (30I.48 × 35.56 cm).

The question of just how much suggestion needs to go into a painting before the subject is apparent is one that has always intrigued me.

I think *Christmas* has enough clues to suggest a traditional wreath composed of evergreen boughs, red holly berries, and a ribbon arrangement. Unlike a real wreath, however, this one's shape is an incomplete circle that fades off into abstraction. Its flowing ribbon is a free form of color, value, and lost-and-found edges. The painting is intentionally ambiguous to encourage the viewer's interpretation. This way the viewer has a greater opportunity to become a participant in the creative process.

On being contemporary

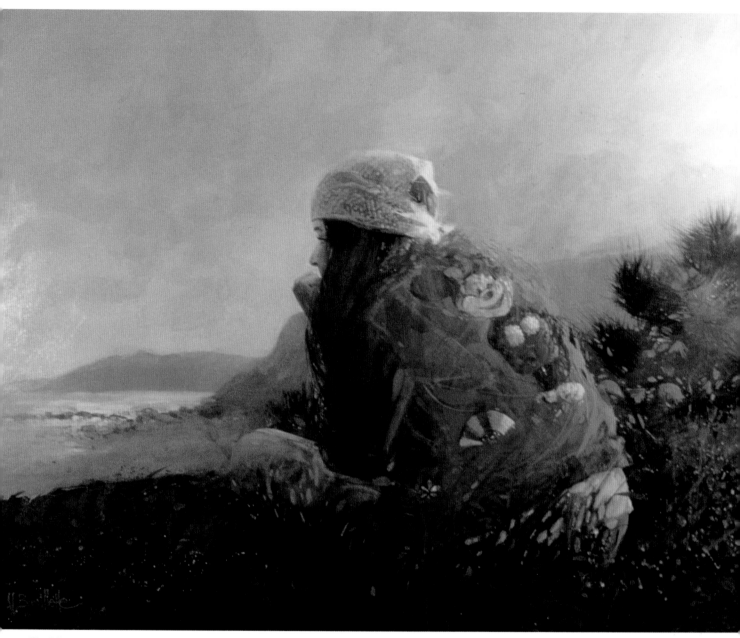

The Mickey Mouse Kid, acrylic on Masonite, 24" × 36" (60.96 × 91.44 cm).

The painting you create is always a new event because it results from an encounter with your experience. It is a reflection of the society you live in. A newspaper writer once asked me if I was a "contemporary painter." With tongue in cheek, I enumerated what I had done that day: got out of bed, shaved, ate breakfast, etc. I concluded that I must be contemporary because I am here and therefore painting under the influence of the twentieth century.

The Mickey Mouse Kid is indicative of my time spent in the 1970s observing its changing fashions. In this case, the uniform of change is worn by my daughter Ann, but I have placed her in an environment that is relatively unchanging. Could this painting have been done in the nineteenth century? That probability is just as likely as the *Blue Boy* being painted today.

The "you" in designing

The Railroad Man, acrylic on Masonite, 16″ × 22″ (40.64 × 55.68 cm).

The Railroad Man can be used as an example of how I used design concepts to make a personal statement. The choices I made when I rearranged the subject were all subjective. The painting that resulted for better or worse is mine.

I began this painting by redesigning the vertical spaces into unequal parts to increase their variety. The interior of the building has been darkened to spotlight the sunlit figure. The points at which the individual boards meet have been orchestrated into a variable theme in line.

The window on the far wall also contains many design decisions. For example, the values that comprise the glass panes range from very light to very dark. The panes were also altered to become less regular. The window's outer edge adds complexity by including a variety of hard, soft, and lost edges. The sunlit and shadow areas on the man's shirt were modified to increase their visual interest.

Reality and imagination

I admire artists who can use the mundane, the discarded, or the overlooked and then transform the ordinary into a work of art. I had been painting for quite a while before I could emulate these risk takers and be a little more spontaneous with my selection of subjects. But once I began to gain confidence in my ability as a craftsman, the least thing that aroused my interest became a possibility for a painting. Then I became able to interpret what I saw personally rather than render it literally.

As an example of this idea, I recently gave my students an assignment to go outdoors and accumulate ideas for the day's painting. After thirty minutes or so had passed, I went out to see how they were doing. As I had suspected, most of them were wandering around in search of the "perfect" subject. In order to make a point, I sailed a frame made out of matboard across the parking lot. At the exact place where it landed, I set up my easel and did a painting of the wild grass and gravel that was framed by the mat.

Although the subject was essential to begin, it became less and less important as the painting took on a recognizable life of its own. Through a process of selection, alteration, and interpretation I was able to develop a painting largely of my imagination.

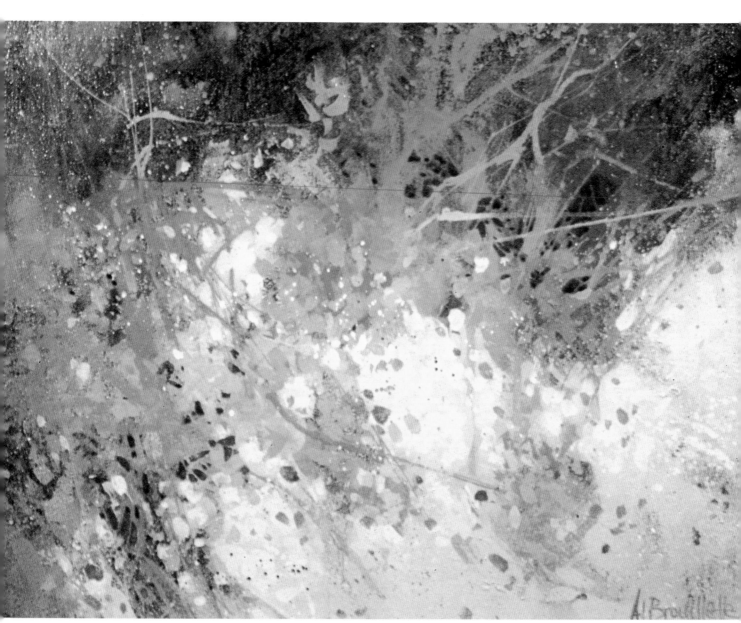

Gravel and Grass, acrylic on Masonite, 14″ × 16″ (35.56 × 40.64 cm).

Freedom to express

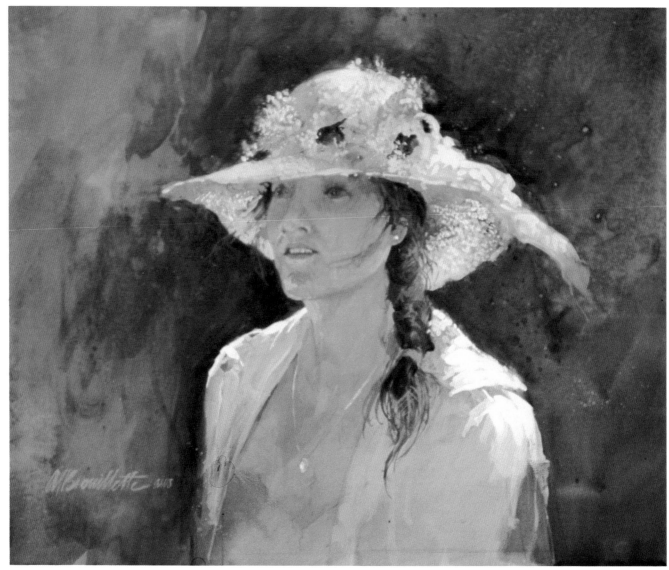

Spring, acrylic on illustration board, 14½" × 17⅞" (36.83 × 45.40 cm).

Although personally interpreting my subject is important to me, on occasion I have kept to a literal interpretation, and consequently I'm disappointed in the completed painting. The reason I get myself into this situation is always the same: I'm copying rather than painting my impression of the subject. When I get involved in methodical accuracy I've given up my ability to make spontaneous, intuitive, and creative choices.

The last time I got caught up in this dilemma was when I bought my wife a lovely straw hat and asked her to pose for me. Unfortunately, I fumbled around so long trying to get a physical likeness that I ended up with a stiff, unimaginative painting.

Once I realized what had happened, I decided it was not important that the figure look like the model, so I asked my daughter Ann to sit for me. This time I felt free to get involved with the creative process. I had a wonderful time, and I was pleased with what I had done.

Expressing your emotions, having a good time with value and color, experimenting, and playing with shapes and edges can be a liberating force. This type of approach is most likely to result in personal satisfaction and creative works.

Using acrylics transparently

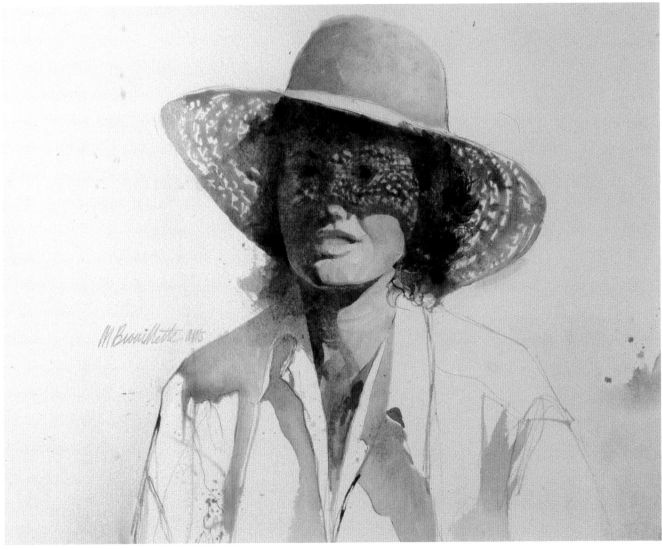

Penny, acrylic on paper, 15¼" × 18¼" (38.74 × 46.36 cm).

Most of my workshops are done for watercolor societies. Usually there are questions about my working with acrylics rather than watercolor. Since most of the students work with "traditional" watercolors and have little information about acrylics as a transparent medium, the inquiries are understandable. To help the students understand my approach, I began my first demonstration using the more traditional methods they are familiar with. This head study is an example of the acrylic medium used in just such a way.

I began with a fairly detailed pencil drawing and then washed in my lightest values. Once they were dry I added my middle, middle dark, and darkest values in succession. I decided to leave most of the shirt white, so I clarified its outline and details by redrawing these elements with a soft lead pencil. When I had completed the painting, the students expressed surprise at the similarities to standard watercolors.

Of course, there are differences. Once acrylic passages have dried, they are very difficult to lift or soften. The positive side is, however, that since acrylics won't lift once they are dry, you have complete control over layering one wash over another, and the possibilities for glazing have been increased.

Negative painting, positive results

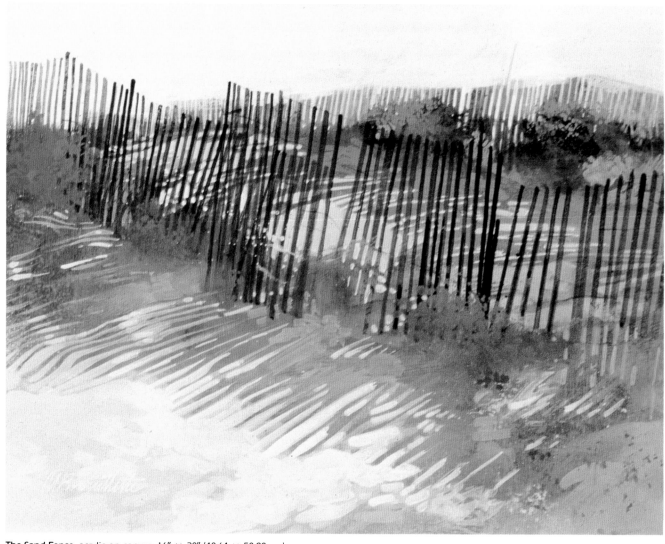

The Sand Fence, acrylic on canvas, 16" × 20" (40.64 × 50.80 cm).

I can remember the first time I deliberately painted negatively. The piece I was working on included a wooden chair. It suddenly dawned on me that the chair could be partially developed by painting the areas behind and around it. This approach gave me another way to shape the subject.

The Sand Fence is a more complex painting than the painting of the chair, but I have developed its contours in the same way. I began the painting by covering the canvas with a middle value. Once the surface was dry, I roughed in the fence line and ground shrubs with my darkest values. The light sky and sunlit ground areas were then described by painting behind the fence and shrubs with opaque colors. I alternated between the transparent darks and opaque lights until the painting was completed. The initial middle value was shaped into the background hill and the shadows cast by the fence and shrubs.

Focusing on the subject alone may cause an artist to neglect a major portion of his painting surface. An awareness of the possibilities for shaping the negative as well as the positive areas can produce images that strengthen the visual effectiveness of your work. The ability to see your subject and the space around it equally will result in superior arrangements of shape and value.

Repetition versus variety

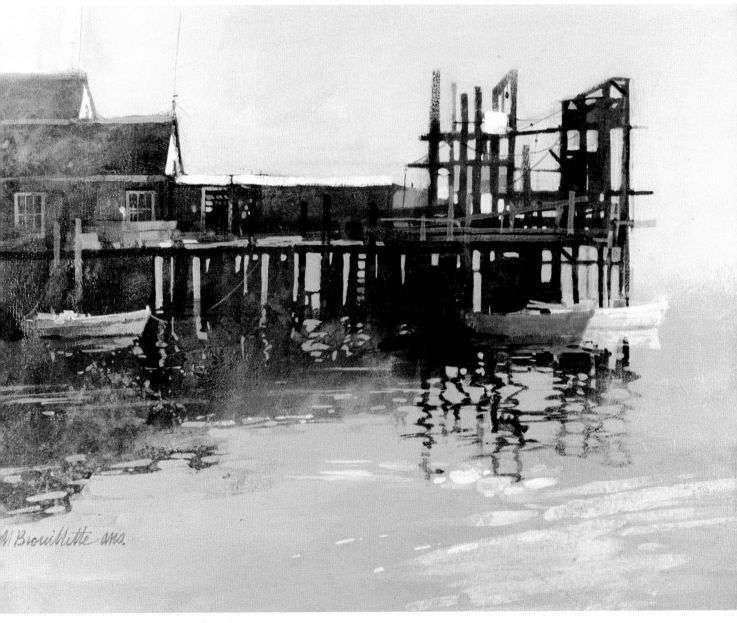

Quiet Morning, acrylic on Masonite, 16" × 20" (40.64 × 50.80 cm).

The structure of the actual dock used as subject matter for *Quiet Morning* is composed of poles that are consistent in shape and size. The spaces between them are also exactly spaced without discernible variations.

When a subject contains repetitive elements, I will make numerous changes during the painting process in order to avoid a static, visually uninteresting image. In painting this scene I made the following changes:

1. The widths, lengths, and values of the poles were varied, as was the spacing between them.

2. Areas of light and dark were added to the structure to lessen its linear dominence.

3. The vertical stance of the poles is continually interrupted by the addition of horizontal countermovements found in the boats, the water, and the building.

4. The reflective image of the dock in the water was altered to avoid additional repetition of forms.

Thus, in this case, realistic description has been avoided in order to increase design variety. The images that were used to represent an architectural structure are now as varied as the trees in a forest. This dock does not exist in reality; it is a creation of my imagination.

The value of painting in a series

What would the results be if you were to do a painting using the same subject as one you painted some time ago? Would there be evidence of a change in style? Your use of color? What about your design concept, the expressiveness of your work, or your final objectives?

The bird's nest series (pages 114–115) showed what happened when I returned to the same subject after an eight-year period. A slightly different situation resulted in the paintings shown here. These works are the result of a six-year effort. It was a case of doing the same subject again and again until I got it right.

These four paintings show a gradual shift in my emphasis. In the first painting I am caught up with the details of the model's clothes. The second painting shows a willingness on my part to leave out some of the facts. The third painting in this series indicates an interest in the play of light and shadows on the model's face.

The fourth painting contains information I learned from the three works that proceeded it, plus a heightened awareness of the need for an effective arrangement of all of my elements into a cohesive design.

At times it has seemed that my evolution and growth as an artist have been almost nonexistent. But when I compare these paintings, I find the experience reassuring. Now I realize artistic change is as normal as breathing if you continue to think creatively.

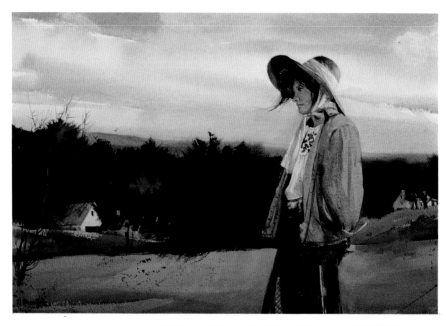

Arrah, 1974, acrylic on watercolor paper, 21″ × 29″ (53.34 × 73.66 cm).

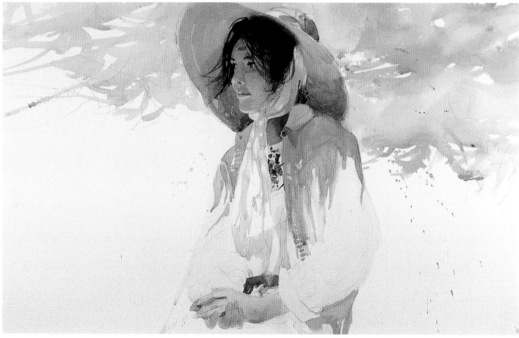

Girl in Straw Hat, 1976, acrylic on watercolor paper, 15″ × 22″ (38.10 × 55.88 cm).

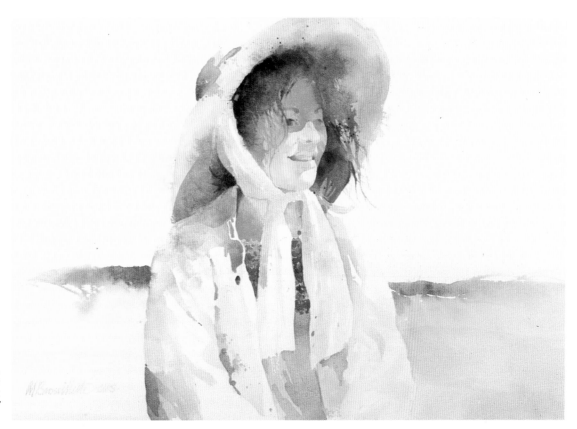

Sunshine Girl,
1978,, acrylic on
watercolor paper,
20″ × 22¼″
(50.80 × 56.52 cm)

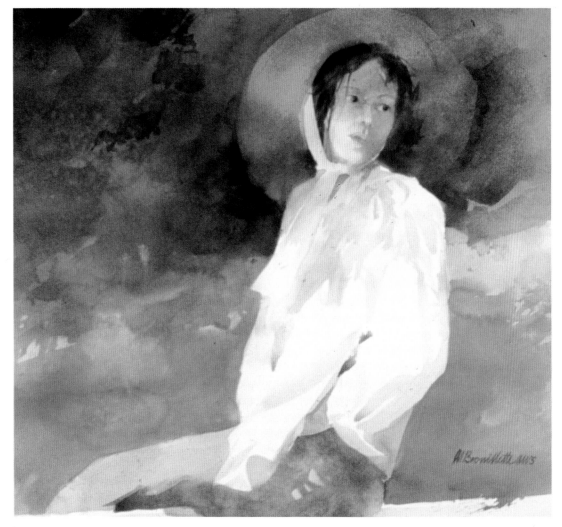

Country Girl,
1979, acrylic on
watercolor paper,
19¼″ × 27¾″
(48.90 × 70.49 cm).

Making up objectives

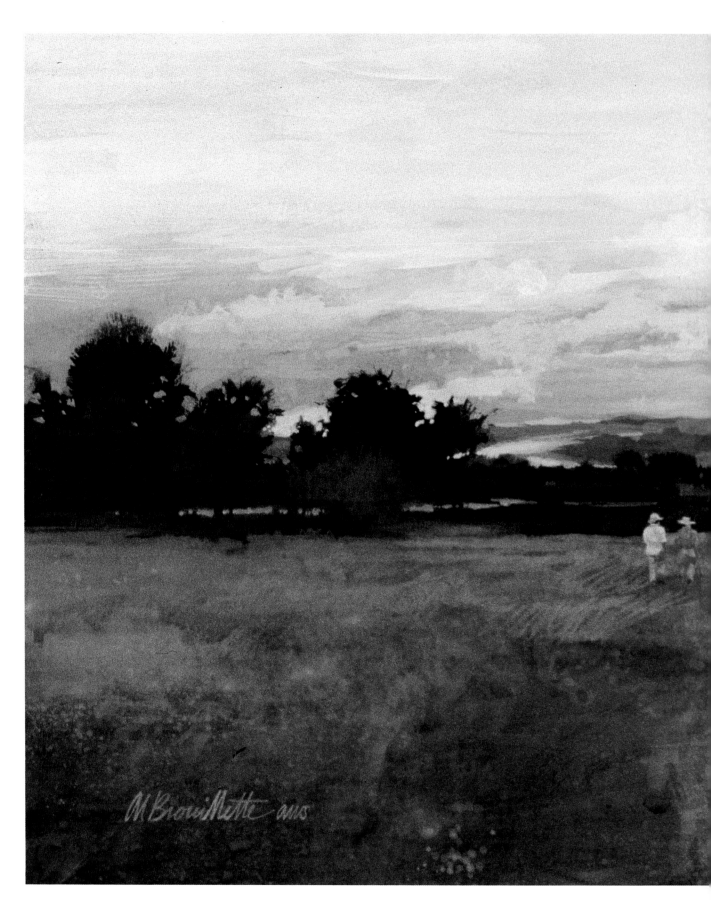

An understanding of why you have chosen a certain subject for a painting should come before you begin to paint it. I see many paintings that are ultimately unsuccessful because objectives were not determined at the beginning. Without objectives the chance of any degree of success is limited.

My intentions for each subject are conditioned by what I see as its primary content. Sometimes color may be the dominent theme, or an atmospheric condition, such as the softness of a landscape on an overcast or rainy day. At other times the abstract pattern of the scene may be what I choose to focus on. For *A Walk in the Field*, the suggestion of depth was my primary motive for painting this particular landscape.

Particular elements in the photographs needed to be emphasized to achieve the spatial effect of depth I wanted. For example, the patterns on the ground grew smaller as they receded toward the horizon. These patterns also had to be made flatter, less detailed, and cooler as they approached the background. The clouds had to be treated similarly as they layered back into the distance. I paid attention to all of these areas as I developed the painting. As a final touch, to give a sense of distance from the foreground, I added two figures to the middle ground.

A Walk in the Field,
acrylic on illustration board,
12″ × 14″ (30.48 × 35.56 cm).

Index

FEB 15 '97

3-17-97

4-17-97